All That Glitters

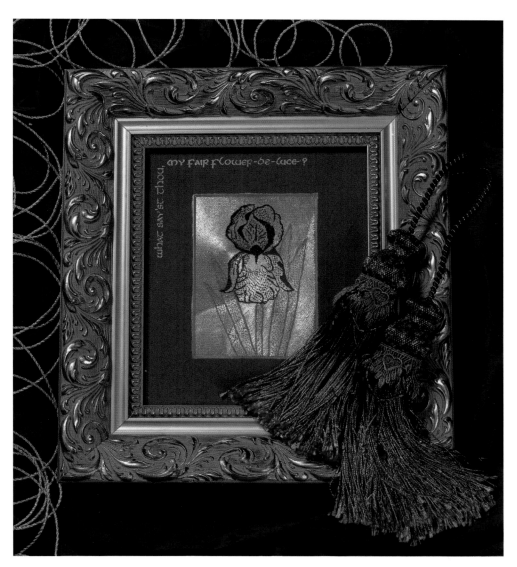

Projects featuring the techniques of Goldwork and Stumpwork

Alison Cole

Search Press

Contents

Foreword

The embroidery world has enjoyed a remarkable renaissance in the last decade or so. This has spawned some extremely talented embroiderers and it is a fitting accolade to Alison Cole that her name should be included in a very select coterie of excellence.

Her decision to write a book, which charts her own rise and achievements, shows a generosity of spirit that will ensure her wealth of knowledge and experience will always be a legacy to others.

Here then is a book written in a clear and concise way, full of practical advice, tips, and most importantly a guide to a series of projects aimed to test and tease out the latent skills that lie within us all.

William Kentish Barnes
Golden Threads,
Brimstone Cottage,
Pounsley, Blackboys,
East Sussex, TN22 5HS,
United Kingdom.

Ph/fax: 01825 831815.
Email: info@goldenthreads.co.uk
www.goldenthreads.co.uk

Acknowledgements

Firstly, I would like to thank all of the people who have encouraged me to write this book. To the many friends and students who have, in the past, asked when I will write a project-based book on Goldwork and Stumpwork – thanks to you, here it is!

Two women who must be thanked for their friendship and inspiration are my mentors Ruth Marks and Lesley Uren. Thanks also to Pauline Harrison. Without the encouragement of these three women I might not have started teaching. Thank you, too, to Morna Sturrock, for the support and encouragement you have offered me.

Thank you to Bill Barnes of Golden Threads for his beautiful threads, prompt service and kind words.

To my mother, Carmel, thank you for the advice, for the times that you encouraged me to take my embroidery studies further and looked after the children so that I could do so, and for the support that you have given.

Last, but by no means least, I want to thank my family – my husband Stephen, and children Sam and Rebekah, without whose support this book would not have happened.

Introduction

This book of designs combines my two embroidery passions – Goldwork and Stumpwork. It is my hope that other embroiderers will fall in love with these techniques as well. While there are a number of Goldwork technique books available, very few project-based books have been written. And so my journey begins…

As long as I can remember, embroidery has been a part of my life.

I have fond memories of my mother's collection of Semco and Anchor stranded cottons, kept in a Violets chocolate box, which I used to sort into colourways and then put away again.

For my fifth birthday, a boy at school gave me a pair of knitting needles and a ball of orange wool, so my mother taught me how to knit a scarf (which is still in my cupboard).

When I was a little older, my mother taught me how to mend my teddy bear (who still looks a little worse for wear), and then how to use the sewing machine – making a patchwork pillowcase out of left-over flannelette.

At eleven, my great-aunt taught me how to crochet. As you can see, I am not an embroiderer by chance – it's in my genes.

The first piece of embroidery that I remember working was a needle-case at school. I embroidered the butterflies mainly in satin stitch and buttonhole stitch. From here I went on to embroider numerous supper-cloths and duchess sets, tapestries and then cross stitches.

The thirst for knowledge about other techniques – especially Stumpwork and Goldwork - led me to join the Embroiderers Guild of Victoria. Here I maxed out on classes – everything from Crazy Patchwork to Casalguidi. I travelled from Ballarat to Melbourne to take Intermediate Certificate classes in Goldwork and Pulled Thread. Then I started working for my friend Pauline Harrison in her embroidery shop – first serving, helping customers and stocking shelves and later teaching classes as well.

I found myself teaching for the Embroiderers Guild, both in country branches and in the city. In 2002, I was awarded the Ethel Oates Scholarship and used the funding to take the Art for the Stitch

Course and to delve deeper into the history of metal thread embroidery.

I have won several awards for my work, both in Australia and abroad. My embroidery has taken me on many travels, teaching all around Australia. I have written for embroidery magazines and now I am embarking on a new challenge – writing a book.

While I have learned many different styles of embroidery, my favourites are Goldwork and Stumpwork, and this is why I specialise in them. It does not matter how much research and study I put into these two techniques, there is always something else to learn. Variations in style and technique, threads and paddings are innumerable. Some of the techniques used in Stumpwork cross over and are also used in Goldwork, so it was a logical step for me to add Stumpwork techniques to my Goldwork and vice-versa. They compliment each other so well! Small amounts of Goldwork threads have always been used in Stumpwork as highlights – metal purls, spangles and couching threads have all made an appearance in historical pieces.

Some of the pieces in this book will be familiar to my students while others have been designed purely for *All That Glitters*. In either case, I hope that you enjoy embroidering them as much as I have.

I have loved my embroidery journey thus far and can only dream of what the future holds.

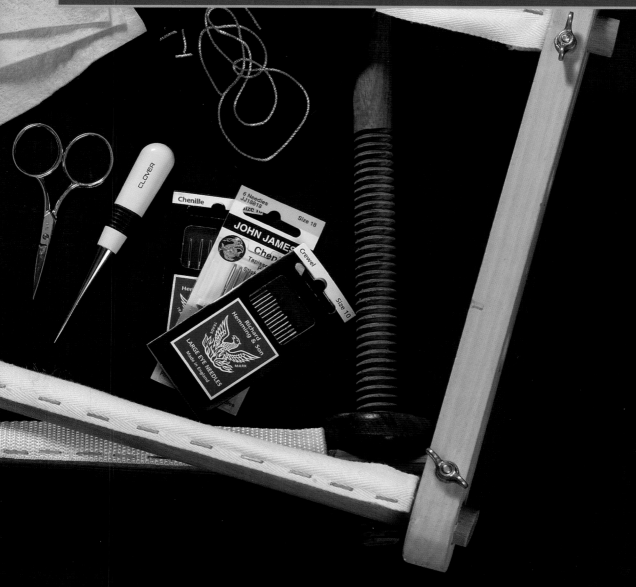

Basic Supplies and Requirements

All of the requirements for the projects in this book are available from specialist needlework shops.

Frames and Hoops

Both Goldwork and Stumpwork need to be held drum tight at all times. For this reason a good quality hoop is a must when working on a small design. I recommend using either a Susan Bates ® Plastic Hoop or a quality beechwood hoop with the inner ring bound with cotton tape.

When placing your fabric into a hoop, always place the join of the hoop (where the screw is) directly at the top of your work (that is, at twelve o'clock if you imagine a clock-face.) The reason for this is that if you place your join on an angle, you will always have a slack point running across the grain of the fabric.

In other embroidery styles we are told not to leave our embroidery in our hoop as it will end up with hoop marks that will not press out. Goldwork and Stumpwork are the exception to this rule. It is true, however, about the hoop marks, and therefore you must use a hoop that gives you enough room around your design for framing.

A 10-inch hoop is the largest that I recommend using – any larger than that and the fabric cannot be tightened to the degree required.

For any designs that are larger – a frame must be laced up. A simple tapestry/lap frame is suitable, as are the more elaborate slate frames.

Preparing the Working Frame

Cut a piece of calico to the same height as your frame but 5 cm narrower in width and press under a 1 cm hem on the top and bottom.

Press under a hem on each side, folding twice to make a casing through which to place a piece of kitchen string/cotton twine. Place the string in the casing against the fold, and pin so that it doesn't move. Sew tacking stitches along this line.

Mark the centre point of the tapes on the frame and centre the

calico on the frame. Pin the calico to the frame, starting in the centre and pulling it tightly as you pin outwards.

Using crochet cotton or perle 12, and using back stitch, sew calico to the frame, top and bottom.

Thread up knitting cotton in a #18 chenille needle and lace the sides of the calico to the sides of the frame, working through the casing. (The kitchen string prevents the cotton from pulling through the calico.)

Pull up the knitting cotton so that the calico is firm but not tight.

Pin your background fabric to the calico from the centre of the top, bottom and sides working outwards with the points of the pins facing inwards. The pins should be about 2.5 cm apart.

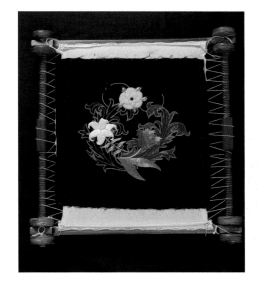

Apply the fabric to the calico using one of two methods. Either work a long stitch followed by a short stitch alternating around the fabric (coming up through the calico and down through the background fabric) or work herringbone stitch around the edge of the background fabric. If you are applying using the straight stitch method and all of your stitches are the same size, when you tighten your frame the stitches will pull away the edge of your background fabric.

Once the fabric is applied, remove the pins and tighten the roller bars of your frame. Next, tighten the cotton lacing the sides of your frame until the frame is drum tight. Refer to diagram.

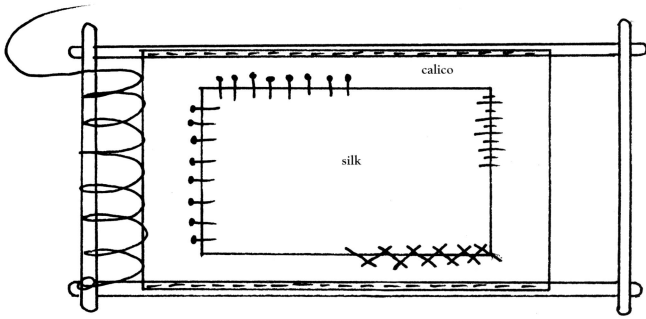

Fabrics

The best fabrics for Goldwork and Stumpwork are those with a close weave. Silks, satins, fine linens and wools are traditionally used. But for those that know me, it's throw tradition out the window – who says that you can't use your favourite patchwork cotton fabric as the background for your design? So long as the fabric is of a suitable weight for the embroidery that is going to be on it and has a close weave, the choice is yours.

One thing to consider when selecting a fabric is the colour. If you wear gold jewellery, take off your watch and lay it on the fabric. If the watch glistens – so will your embroidery. If the watch disappears – so will your embroidery! While darker colours are more suited to Goldwork, white, ivory and biscuit tones look elegant.

Always back your Goldwork with a good quality calico, pre-washed and pressed before using.

Paddings

 A wide variety of paddings are available to the embroiderer, most of which have been used for centuries.

Felt – this can be used for a slight padding to a high relief padding. I recommend using a wool blend felt as it is softer and less fuzzy to work with. If a smooth, mounded shape is required then layer the felt from the smallest to the largest piece. If an organic, rougher shape is required, layer the felt from largest to smallest – an example of this could be the centre of a waratah flower.

Felt can also be stuffed with a polyester fibre filling (toy filling). Apply the felt and stuff with fibre as you go. The felt expands more in larger areas and less in smaller ones, which makes it terrific for bodies.

String – this comes in forms from a fine kitchen string to a thick builder's twine, and is a wonderful padding. Purls and couching threads can both be laid over the top of cotton string to create basketweave patterns or bumps and ridges if that is what's required.

Soft Cotton – this can be used in a number of ways, for example, a padded area can be built up with stitches overlaying each other or the soft cotton can be couched down in a linear design to raise stems, branches and decorative lines. This is a terrific padding if you want the padding to taper.

Cardboard – padding with card is an age-old technique. Whether a single layer of card or multiple layers, this type of padding gives a flat, raised surface with a clean, sharp, right-angled edge.

Other objects – a wide range can be used to raise a surface to embroider over, for example, jump rings, brass and plastic rings, beads and even felt corn pads.

Metal Threads

Goldwork threads can be placed into one of two main categories, according to their application – they are either couched down onto the surface or they are hollow and sewn onto the surface like a bead. Goldwork threads are expensive, so why would you want them to be on the back of your work? There are exceptions to this for example, passing thread, which can be placed into a chenille needle for

embroidering with as you would a regular thread. Let's take this opportunity to discuss some of the more common, and some of the less common threads that are used in this book. There are, of course, many more threads than those mentioned here.

Purls

Smooth purl (shiny), rough purl (matte) and bright check purl (faceted) are all hollow and are cut to length and sewn to the surface of your fabric like a bead using a waxed thread. They are like miniature springs and as such will bend and flex to follow any padding that you have used. These threads are easily damaged: they can be squashed and stretched out of shape. However, they can take on a lace-like appearance when deliberately overstretched, scrunched up and couched down.

Smooth, rough and check purl are available in gilt, silver and copper, while rough purl is also available in a number of colours, rusty red, bottle green and purple to name a few.

When purchasing smooth, rough or check purls, note that the larger the number, the finer the thread, for example, Smooth Purl #10 is finer than Smooth Purl #6.

Pearl purl is the exception to the above – there are three ways in which to use it. It can be cut and sewn like a bead but generally it is couched onto the surface of the fabric. Excepting the very fine pearl purl, it can be couched directly onto the fabric, with the thread disappearing between the coils of the thread. The third method is to stretch it out slightly before use and then couch onto the surface of your fabric. As a guide, stretch so it becomes approximately 50 per cent larger – for example,10 cm becomes 15 cm. Pearl purl can be stretched further, but remember that it doesn't go back so take it gently. Alternatively, it can be stretched until it is almost straight for a completely different effect.

When stretching the pearl purl, stretch enough for the area that you are working in – if you couch it down and then need to stretch a bit more, you will be guaranteed to have a mark where you have started

and stopped. After stretching your first section of purl, move your hands further along so that the area yet to be stretched also incorporates a couple of centimetres of already stretched purl. This already stretched purl will not stretch any further until the new piece that you are stretching is the same size.

If you are looking to add a small amount of colour to an area, silk thread can be run through the pearl purl after it has been couched to create a barber-pole effect.

When purchasing pearl purl, remember that its sizing runs in the opposite direction to the other purls. The larger the number, the thicker the thread – Pearl Purl #2 is thicker than Pearl Purl #1 (Super Pearl Purl is the finest). In America, pearl purl is called Jaceron.

Smooth Purl #6

Rough Purl #6

Bright Check Purl #6

Gilt No. 5 Check Thread

Gilt Fine Rococco

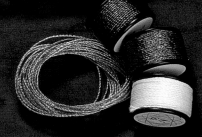

3 Ply Twist

Gilt Flatworm

Whipped Plate

Broad Plate

Couching Threads:

Kreinik Japan Thread

COU-371

T70 & T72

Coloured Rough Purls

Pearl Purl #1

Gilt Milliary Wire

Gilt #1 Twist

Medium Grecian

T70 Jap 3 x 2 Cord

#18 Pailliettes/Spangles

4 Ply Gilt Bright Gimp

Gilt Tambour Thread

Smooth Passing Thread

Cotton On Creations 608 & 614

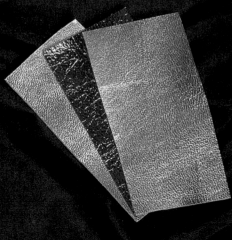

Kid Leather

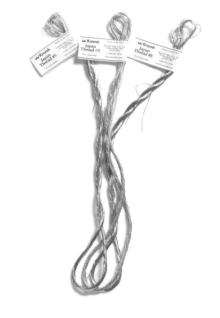

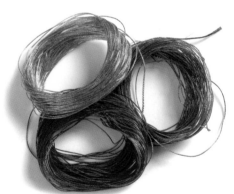

Other Threads and Materials

Brass mesh comes in varying sizes, the finest of which looks like organza. It can be stitched through, cut to size and moulded to shape making it a versatile material. It is also available in copper.

Couching threads belong to a large family. These threads, too, are applied with a waxed thread, and as the name suggests they are couched on the surface, with beginning and ending tails of thread taken through to the back of your work with a chenille needle to be secured to the calico.

Japanese gold was originally a couching thread made up of strips of flattened gold wound around a core thread. Later, gold leaf on paper wound around the core thread. Today, a metal alloy is painted onto rice paper and wound around a core thread.

Variations of couching threads are sometimes called Japan thread, Imitation Jap, or T70 among others. Couching threads are available in a multitude of metallic colours, not just gold, silver and copper. Imitation Jap is also available in cords of varying sizes.

Gimp (4 ply) is a cord made up of four passing threads.

Gütermann thread is used for all Goldwork – whether threading or couching – in this book. The thread is a Gütermann polyester or silk thread, colour number #968 and should be run through wax. Other threads that can be used in place of Gütermann are YLI Silk #50 or #100 or Pearsall's Gossamer Silk.

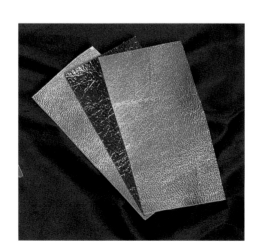

Kid, as the name suggests, is kid leather. It is cut and applied with stab stitches in the same manner as laying felt padding. Kid comes in a variety of colours, not just gold – pewter, silver, metallic pink, bronze to name a few. It only has a little give to it, so if laying over padding, remember to cut slightly larger than your padding pattern to ensure coverage.

Metallic organza has a warp and weft made up of polyester threads and metallic polymide threads. It is applied to the base fabric with small split backstitches which are then covered with another thread (for example, pearl purl.) I use metallic organza in place of cloth of gold.

Milliary wire is similar in appearance to pearl purl that has already been stretched. It is joined onto a base wire and, as with pearl purl, looks fantastic when a thread is run through the centre after couching. It, too, is available in gilt, silver and copper.

Passing thread is a fine wire wound around a core thread. It can be sewn with in a chenille needle or couched on the surface. I like to use Smooth Passing Thread #6 when working Or Nué pieces as it gives such a lovely light reflection within the design. It is also available in gilt, silver and copper.

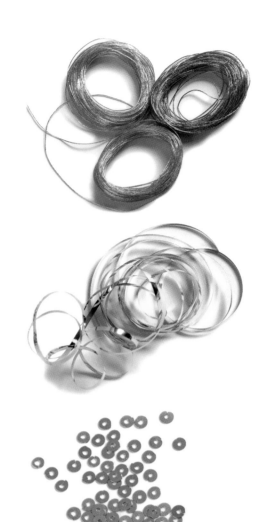

Plate or broad plate is a fine ribbon of metal and is also available whipped with a fine wire. It can be put through a ribbler to achieve a crinkled effect. (Ribblers are sold through papercraft shops to give a corrugated effect to paper and card.)

Rococco and check threads are couching threads that have a kink or wave in them. They come in various thicknesses.

Spangles/paillettes are made of brass or gilt brass wire that is pressed, giving the spangle its distinctive 'squashed sausage' shape. Sequins can give a similar effect – they are stamped out of a sheet of plastic.

Twist is a fine cord made up of couching threads.

Needles

For each project I have listed the needles required, but generally, I find that the most used needles in Goldwork and Stumpwork are #10 crewel needles and #18 chenille needles.

In my travels as a teacher, I have found that needles tend to confuse people. Not everyone can identify their needles once they are taken out of the packet. And while we have all embroidered a lovely needle-book at some time or another, with doctor flannel pages to keep our needles in, I find that the most practical needle-book is a business-card holder. Each needle can then be kept in its packet and the packet placed in the card holder. Of course, you can embroider a lovely cover for your business-card holder and any stray needles can still be kept in your flannel needle-book.

Other Requirements

You will need a few basic requirements for Goldwork embroidery. The first is something that you can make for yourself. A cutting pad is needed to cut purls on. As purls are essentially miniature springs, if you cut them on the table, they will jump around. If you cut them on your work, you will end up with small chips of gold that will work their way into your background fabric. The other problem with cutting purls on your work is that as you lift them from your work, one could catch on the background fabric and pull a thread out.

To make a cutting pad, cover a piece of cardboard approximately 10 cm x 15 cm with velvet. A polystyrene tray from the supermarket also makes a terrific cutting pad when covered with velvet. The covered tray can be pinned to your frame while working, the lip of the tray preventing purls from rolling off the pad.

When travelling with your Goldwork, an old jewellery box makes a great cutting pad (and you can close the lid when finished and not lose any purls).

Sharp, fine scissors are also required – but not your good embroidery scissors as purls will damage them. There are a few choices, for example, you can use Goldwork scissors which have a serrated blade; buying yourself a new pair of embroidery scissors and retiring your old ones to cutting metal thread; or using a pair of nail scissors (not nail clippers).

Do not use pliers, nail clippers or a craft knife to cut your purls, as these items will squash them before they cut and damage the ends.

When cutting out detached elements for Stumpwork, my favourite scissors are KAI Ultrasharps. They have an exceptionally fine blade, making cutting out a dream.

Purls are metal and will wear your thread – waxing (I use beeswax) helps in prolonging its life. After waxing your thread, remember to run your fingernails down the length to remove any excess wax. If you don't do this, excess wax will flake off onto your background fabric and be difficult to remove.

A tailor's awl is a useful tool to have in your workbox, as are a pair of tweezers and a fine-toothed comb.

For transferring designs, GLAD Bake ® (a strong, wax free, see through baking paper), a mechanical pencil, dressmaker's carbon and a stylus or empty ball-point pen are invaluable.

Scotch ® Magic Tape ™ (available from most supermarkets) is great for holding things in place (especially while transferring designs). It does not leave a sticky residue on your work like regular tape does.

A clamp to hold your frame or hoop on the edge of a table leaves both hands free to embroider with. I use Irwin quick-release clamps – they can be operated with one hand and are easy to use.

Framing

When you take your embroidery to the picture framer, it is a good idea to ask, 'Have you framed any Goldwork before?' If the framer has not, show him or her some scraps of your purls and demonstrate how they can be stretched and squashed out of shape. He or she will then have a greater understanding of the technique and how to handle it while framing.

Another question to ask is, 'Can you leave the frame unsealed for me to check?' My wonderful framer only seals the back with four small pieces of tape so that I can check that everything is OK before it is sealed up. With any pieces that have detached elements, it is nice to be able to shape them (or re-shape them) if required.

The following are a few hints for when you visit the framer.

1. Leave your work in the frame or hoop. It is much easier to place a mount and frame against your embroidery and hold it up to look at while it is in the frame or hoop.

2. While the embroidery is sitting on the framer's table with the mount and frame on it, hold your hands together to make a triangle-shaped opening between them. Position your hands so that when you look through the triangle opening, all you see is a portion of what looks like a completed, framed embroidery. It will give you a good idea of what the completed frame will look like against your work.

3. When you have finished selecting a frame, unlace the embroidery from the frame or take it out of the hoop and place it in a box with a lid that is large enough to accommodate the design without folding it. Your embroidery will now be protected from anything that might be accidentally dropped or placed on it.

At this stage I must also thank my framers Gill and John Shiell, of Masterpiece Frames, in Ballarat, for looking after my embroidery framing requirements so well. All of the framing in this book has been done by John.

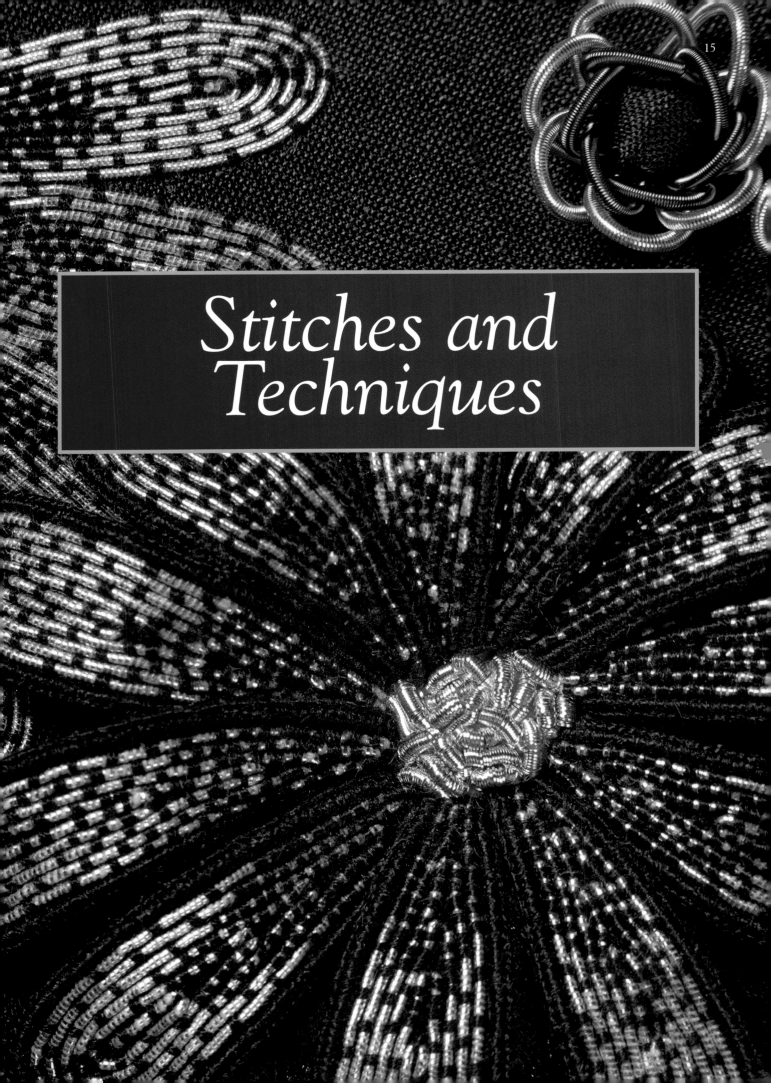

Stitches and Techniques

Most embroiderers have a shelf full of stitch books and magazines with stitch diagrams in them. For this reason, I have not covered the more common stitches but have instead concentrated on stitches and techniques pertinent to the projects in this book.

In this section I have concentrated on the techniques that are common to the majority of the projects in this book. There are more techniques in the instructions for each project, for example, applying metallic organza, trellis work and applying purl over kid.

Transferring Designs

There are lots of methods for transferring designs onto your base fabric. The three that I use the most are listed below. Always place a support underneath your frame or hoop when transferring a design to give a firm surface to work with.

Making Your Own Carbon

To make your own carbon for transferring designs onto light-coloured fabric, trace the design onto GLAD Bake ® with a mechanical pencil and mark which side is the right side up so that you do not reverse the design.

Turn the tracing over onto a clean sheet of paper and re-trace the design, still using the mechanical pencil.

Turn the tracing right side up, place over your base fabric, and re-trace again, this time using a stylus or spent ball-point pen.

Dressmaker's Carbon

To transfer designs onto dark-coloured fabrics, again trace the base design onto GLAD Bake ® with a mechanical pencil and again mark which side is the right side.

Place the tracing over your base fabric, slide the dressmaker's carbon in between (carbon side down), and re-trace using a stylus or spent ball-point pen.

Tack Tracing

This method involves tracing the design onto white tissue paper with a mechanical pencil. Place the tracing over the background fabric and pin in place. With a polyester thread in a #10 crewel needle, stitch running stitches through the paper, following the design. When the entire design has been stitched, tear away the tissue paper, leaving the stitches to follow.

Paddings

Felt

When applying felt, consider the final effect that you are aiming for. When a smooth, mound shape is required, layer the felt from the smallest to the largest piece. Apply the smallest piece with four stab stitches at the extremities (think of 12, 6, 3 and 9 on a clock-face). Continue to layer as many pieces of felt as required with these four stitches until you come to the top layer.

Apply the top layer with the same four stitches, then place another stitch in between each of these and finally work stitches all around the shape approximately 2 mm apart.

Always bring your needle up through your background fabric and down through the felt as this gives more control over the application. Do not try to skip the first foundation stitches that are holding the felt in place – if you start stitching the felt 2 mm apart and work around the whole design without the first foundation stitches, the felt will stretch out of shape and you will have a baggy area by the time you get back to where you started.

If you are wanting to create a rough, earthy base for stitching on, layer the felt in the opposite manner, that is, from largest to smallest. If wanting to create texture, do not place stitches 2 mm apart all around the shape, otherwise you will smooth out the texture.

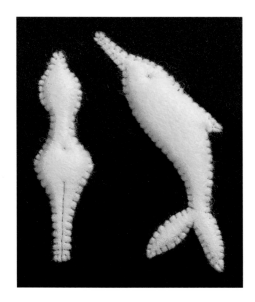

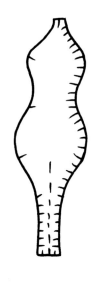

Stuffing wool blend felt with polyester toy filling can also be utilised to give a smooth, rounded padding for a figure. Apply a single layer of felt to your base fabric, again couching at the extremities. As you work your way around the shape with 2 mm stitches, stuff with polyester fibre until the required size is reached.

As the felt has more give over a larger area and less give over a small area, the padding will mimic human and animal forms, for example, being wider at the hips and smaller at the waist.

Cotton String/Twine

Fine string padding is applied simply by couching in place. Begin and end with two or three couching stitches close together so that you can cut the string off neatly against the stitches. Always bring your needle straight up and down to ensure maximum fabric being held. This will make your string padding more secure and less prone to wobbling around.

When padding with a thick string, apply the same as for the fine string, except that you can bring your needle up in between couching stitches, taking it down and piercing the string on opposing sides.

Soft Cotton

Soft cotton can be applied in a number of ways. You can simply build up an area of stitching, layering satin stitch over itself until the desired shape is reached.

Soft cotton can also be couched in place to pad linear shapes. Run the desired number of lengths of soft cotton through wax, and

remove any excess wax by running your fingernails down the cotton. This will help to hold the lengths together and will also prevent any fluffiness from detracting from your design.

Begin and end by couching two or three stitches tight so that the ends of soft cotton can be trimmed off close. Couch the length required inside your design line, being careful not to couch too tight – you do not want your padding to look like a string of sausages!

If your design tapers, trim off lengths of soft cotton from underneath the bundle as you couch the length of the design. In this way the padding will taper without hairy ends poking through the padding on the top.

Cardboard

Card can be applied by stitching through the layers of card, but I prefer to couch over the top of the card. Use a number of couching stitches so that the card shape cannot move from where it is being placed.

Brick Stitch Couching

Before using your couching threads, it is advisable to wind them carefully around a felt-covered tube (such as a toilet roll). They get tangled easily, and it is easy to damage them when untangling.

When couching in brick stitch, cut two lengths of couching thread about 1 m long, and use a length of Gütermann thread that has been run through wax. Begin with two small couching stitches, right beside each other, leaving a 2.5 cm tail of couching thread to take through to the back later.

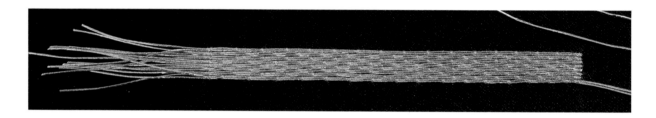

Make couching stitches along your design line approximately 3 - 5 mm apart, keeping the stitches evenly spaced.

To couch in brick stitch means that on every subsequent row to this first row, the stitches are in between the stitches of the previous row, like bricks in a wall.

When working the subsequent rows, bring your needle to the surface on the inside of the design to be filled and take the needle down on a 45-degree angle underneath the previous row. In this way the threads being laid will lay neatly side by side with the last row with no gaps.

• down
• up

When you get to a point or need to turn, each thread needs to be couched down separately. When couching a point, start with the outside thread. Bring your needle up on the inside of the shape, hold your sewing thread tight and bend your couching thread around it. Then take your sewing thread down to the back on the outside of the shape. Turn the inside couching thread in the same way.

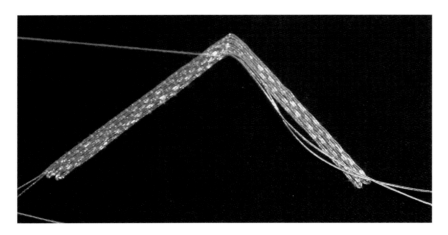

When turning 180 degrees, turn the inside thread first. Make your last couching stitch about 2 mm away from where you want to turn. Turn the inside thread, then the outside thread, then make a couching stitch over both threads that will be level with the last of the previous row. After this, continue bricking.

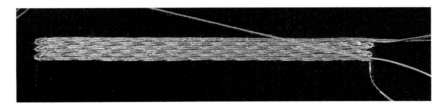

When the angle becomes too acute to get the two couching threads to turn, dovetail the couching threads. This means to couch to the end, cut your threads leaving a 2.5 cm tail (to take through to the back), and begin again (again leaving a 2.5 cm tail). When taking the ends through to the back with dovetailing, take the outside threads through one at a time and then the inside threads. For example, outside left, outside right, inside left, inside right.

To take the ends of thread through to the back of your work, thread the tails through a #18 chenille needle one at a time and pull through. Once at the back, secure the tails of couching thread to the calico.

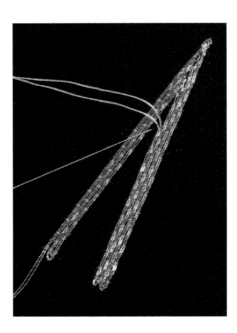

Applying Kid

When applying kid, trace the design onto GLAD Bake ® and mark which side is the right side. Place the right side of the pattern against the back (wrong side) of the gold kid and tape in place. (If you tape the pattern to the top of the gold kid, the tape will destroy the kid when you peel it off.)

If your kid is being applied over padding, make sure to cut out the kid larger than the felt padding pattern. If there is only one layer of felt padding, then the kid will only be a slightly bigger than the felt. If the kid is being applied over a large quantity of felt layers, make sure to cut out the kid allowing for it to cover the padding.

When applying, you want the stitches to be nice and fine, but if you couch too close to the edge of the kid, the needle will pull though and leave a hole in the edge. Bring your needle up through your fabric and down through the kid, as this gives greater control over your stitching and you won't risk putting a hole in the kid where you don't want one to be.

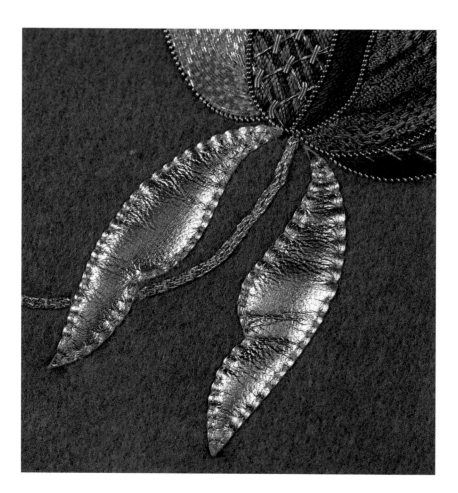

Kid is applied in the same manner as felt – couching the extremities and the halfway points, and then all around the shape 2 mm apart.

If you are finding it hard to control the kid as you are applying it, a great hint is to couch the kid in place with a different-coloured thread to remove later. You are not piercing the kid, simply holding it in place by stitching from either side.

If you have a design that requires you to lay threads over kid, there is a way to bring your needle up in the correct place first time. If you bring your needle up to the surface very slowly, you can see a small bump made by the point of the needle before it breaks the surface of the kid. You can then drag the needle to where it needs to be before pushing through the surface.

Making a Noose with Metallic Thread

When using a thread like Madeira #3 or the synthetic invisible threads, it is a good idea to make a noose around the eye of the needle. This will stop the Madeira #3 metallic thread from slipping out of the needle if you drop it. To do this, thread the needle and then pass the thread back in the direction that it came from, forming a loop.

Pass the point of the needle through the loop and tighten around the eye of the needle. Occasionally, this noose does let go, but most times it keeps the needle and thread together. This method also works with Nymo thread when you are beading.

Or Nué

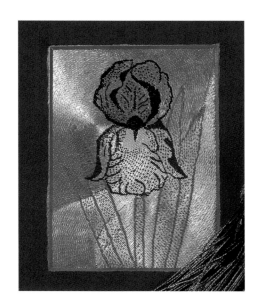

Or Nué is a Goldwork technique that flourished in the fifteenth century. It is also known as Italian Shading and Burgundian Embroidery. Or Nué is French for 'Bare Gold' and is basically thread painting with couching stitches. Historical pieces show the artistic skills of the designer and embroiderer, (for they were not always the same person), in shading draped clothing and curtains to give the design an almost three-dimensional look.

Traditionally, the couching threads were laid horizontally – either singly or in pairs – reflecting one plane of light. The modern way is to couch in a circle, thus giving two planes of light and adding more life to the embroidery. I like to work Or Nué with a circle and a wave shape as this gives even more light planes and thus reflections, depending on how and where the threads are placed.

The colour in the design develops from the couching stitches in silk. The closer together that you place the stitches, the more dense the colour will be. The stitches can be like miniature satin stitch – completely covering the gold passing thread – but a design has more life when it reflects light through it, so completely covering the gold passing thread sometimes defeats the purpose.

Where part of the design is to remain purely gold, the gold passing thread is couched with a thread of silk or cotton in a colour to blend in with the gold. By using one strand of Madeira #3 metallic the thread disappears into the gold passing thread almost entirely. Synthetic invisible thread can also be used to couch the gold backgrounds, but it is slippery and hard to work with.

Purls

Smooth, Rough and Bright Check Purl

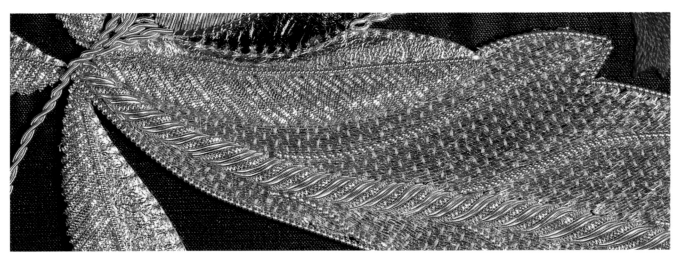

As discussed earlier, purls are cut to length and sewn down like a bead. They are usually laid over a base padding, but can be laid directly onto your base fabric.

When applying purls to an area, think of when you embroider in satin stitch. Don't try to start to lay purl at the edge of a shape: it is easier to begin in the middle and work outwards.

The purls need to be cut to length so that they lie side by side, making sure that the purl touches your fabric on both sides if using padding.

If a purl is too long it will hoop upwards and if too small there will be a space on one or both sides. These purls need to be removed and replaced with a purl of correct length. Having said this, there are times when this is the effect that you are looking for, for example, stamens in a flower.

If a purl is too long and you simply pull on the Gütermann thread to make it fit, it will develop a crack which will appear as a dark spot in your embroidery.

When laying purls, always work on the light side. This means that after you have laid the first purl, bring your needle up on the side furthest away from you in the direction that you are working. It is much easier to judge the distance on this side. Have a look at the diagrams opposite.

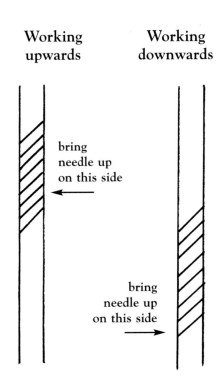

Working upwards **Working downwards**

bring needle up on this side

bring needle up on this side

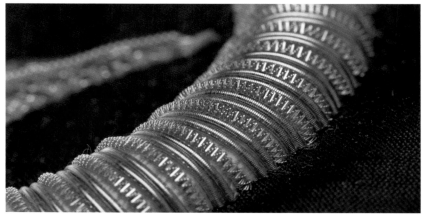

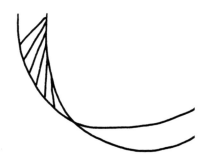

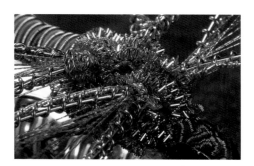

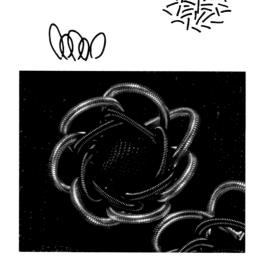

When laying purls around a curve, it is necessary to leave a small gap between the purls on the outside edge. Do not try to apply a short piece of purl in this gap, as the end of the short purl will appear as a dark spot and draw attention to itself. If you have yellow padding under the purls, the gap will not be seen.

Chipping is laying small pieces of purl in a random fashion. The more different directions that the chips face, the more light that they reflect (especially if using bright check purl). When chipping with smooth and rough purl, the effect looks like a mass of golden maggots – sounds disgusting but looks fantastic!

Hooping is laying purls so that they deliberately sit up – like working bullions for Brazilian embroidery). Take the needle up, thread on a length of purl and then go down through the base fabric in the same spot (or almost the same spot) so that the purl has no choice but to hoop upwards.

Pearl Purl

As mentioned earlier, pearl purl can be sewn on as a bead, but generally it is couched onto the surface of your work.

Place a couching stitch in both of the first two coils and then after that, couch approximately every four coils. Couch to almost the end and then cut your pearl purl to the desired length. End as you began by couching in the last two coils.

When going around a bend it is necessary to couch closer. If working fine twisting tendrils that overlap each other, couch either side of where the pearl purl crosses, on the pearl purl that is overlapping.

Ladder Stitch

Ladder stitch is used to join two pieces of fabric together. It is like working a simple running stitch except that every second stitch is worked in the piece of fabric to be joined. When pulled tight, the stitches all run end to end and a smooth join is created. Hint: Do not try to stitch a whole area and then tighten as your thread will probably break. Instead, make three or four stitches and then tighten – keep stitching and tightening until the fabrics are joined. The diagrams below show how to join two flat pieces of fabric, and apply a round shape.

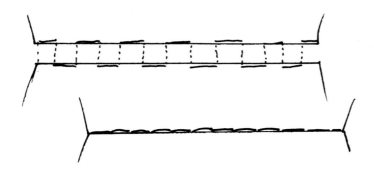

Long and Short Stitch

Those that have participated in class with me know that I call long and short stitch 'long and longer'. Long and short stitch seems to be the most feared and loathed stitch amongst embroiderers. Here are my hints for perfecting it.

Hint Number 1: *Correcting uneven edges*

The first problem that people encounter is that they get an uneven edge when working long and short stitch or satin stitch. This is because sometimes you are stitching through the weave of the fabric and sometimes you are stitching through the threads of the fabric. When the embroidery thread passes through the weave, the tension pulls it, causing it to sit lower than a stitch passing through the thread of the fabric.

To overcome this, long and short stitch and satin stitch should always be outlined with a row of split backstitch. This row of stitching stabilises the fabric, giving you an even finish to your long

and short stitch. It also raises the edge of the long and short stitch ever so slightly. Remember that the smaller the split backstitches are the more that they are doing.

Why split backstitch and not split stitch? I have found that when people use split stitch they are so concerned about coming up and splitting the stitch that they do not realise that they are not coming up on their design line. By working in split backstitch, you are splitting the stitch on the way down and pinning it to the design line.

Hint Number 2: *Stitch direction*

The first row of your long and short stitch should come up through the centre of the design and take the needle down to the back over the row of split backstitch, that is, you work away from yourself.

All subsequent rows should bring the needle up through the existing stitching and be worked in the opposite direction.

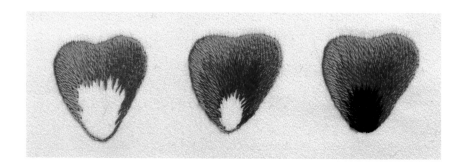

You may bring your needle up between the stitches and you may split stitches – don't worry about bringing the needle to the surface, just worry about where on the surface it needs to be. Which leads to…

Hint Number 3: *Avoiding horizontal banding*

The third problem that people have is horizontal banding. Do not make every second stitch the same length. Vary the length of your stitches – long and short stitch could be renamed to long and longer stitch. None of the stitches are going to be particularly short unless you a working in a small shape or around a sharp bend. Also remember that you are varying where you are bringing your needle up and taking it down.

Hint Number 4: *Don't share a hole*

On most stitch diagrams for long and short stitch, it appears that where one stitch ends the next one begins. When two stitches are embroidered end to end sharing the same beginning/end point, the tension of the stitching creates a hole. Avoid this practice – you are better off to split the stitch rather than share a hole at its base.

Hint Number 5: *Changing colours*

When changing colours in long and short stitch, always stitch past the line that you want the colours to change. In this way, when the stitches come up through the existing stitching, they appear to be on the line where you want the colours to change. Check out the diagram.

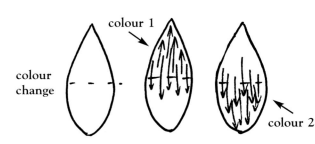

Hint Number 6: *Work from the background to the foreground*

If you are working the petals of a flower, outline the back petal first and then work it in long and short stitch. Then outline the front petal and work it in long and short stitch. By working in this way the split backstitch of the front petal will appear to lift the edge of the petal to make it look like it is really overlapping the back petal.

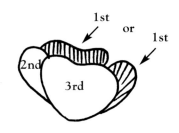

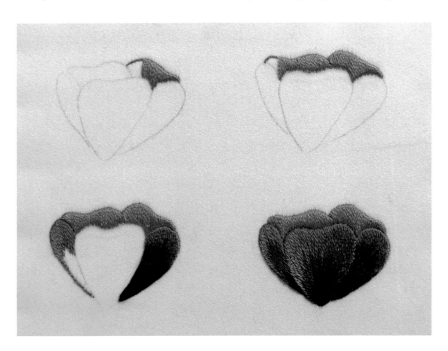

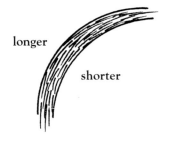

Hint Number 7: *Working around a curve*

If you are working long and short stitch on a long shape that has a curve to it, for example, a stem, work longer stitches on the outside of the curve and shorter stitches on the inside of the curve. If you work longer stitches on the inside of a curve you will lose the curve – it will straighten out and begin to look like an octagon.

Overcasting

Overcasting is stitching side by side like miniature satin stitch, usually over wire in Stumpwork or over soft cotton as a padding for a stem.

Buttonhole Stitch

Buttonhole stitch is also sometimes called closed blanket stitch. Do not confuse it with tailor's buttonhole stitch, whereby the fabric is cut first and then a knotted edge is applied.

When beginning buttonhole stitch over wire in Stumpwork, it is advisable to start off with a chain stitch – that way the start of your first stitch is inside the detached shape.

Bring your needle up on the inside of the wire shape. Take it down in the same place, re-emerging on the outside of the wire shape and bringing the needle through the loop.

For all subsequent stitches, take the needle down on the inside of the wire and up on the outside of the wire, through the loop.

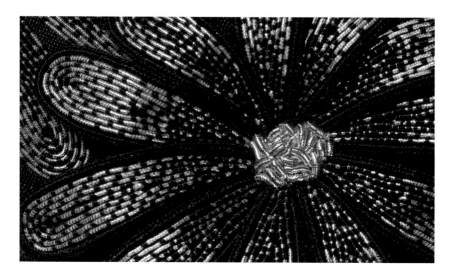

Long and Short Buttonhole Stitch

This is a stitch that I utilise in Stumpwork to eliminate the heavy
edging that regular buttonhole stitch can give to petals and leaves. It
can be used on any petals that have a rounded shape, or on petals
that are pointed and have a central vein. It is also suitable for most
leaf shapes as well, especially pointed leaves with a vein in the centre.
I have also used this stitch in conjunction with regular buttonhole
stitch for butterfly wings, working the regular buttonhole until I am
on the correct angle to launch into long and short buttonhole, and
then finishing the shape with regular buttonhole again.

Long and short buttonhole stitch is worked as for regular buttonhole
stitch excepting that the needle is taken down further into the
design.

When using this stitch as an edging for Stumpwork, care must be
taken with the preparation of the wire. Instead of the usual handful of
couching stitches holding the wire in place awaiting the buttonhole
stitch, the couching stitches need to be placed 2 mm apart around
the shape. This is because the long buttonhole stitch will not be
holding the wire in place as regular buttonhole stitch does.

With regular buttonhole stitch the
stabilising split backstitch edging is
embroidered after the buttonhole
stitch although, of course, it
cannot be worked after long and
short buttonhole stitch is applied.
Once the couching stitches have
been applied, the split backstitch
must be worked next.

Again, start with a chain stitch
before working the long and short
buttonhole. Sometimes it is
necessary to take the needle down
in the same place two or three
times to adjust the angle on the
outside edge to accommodate the
design.

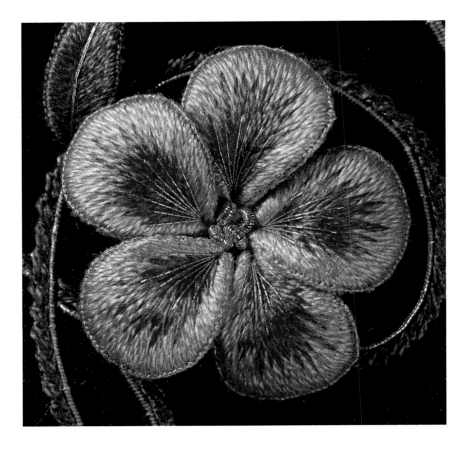

Changing Threads with Buttonhole Stitch

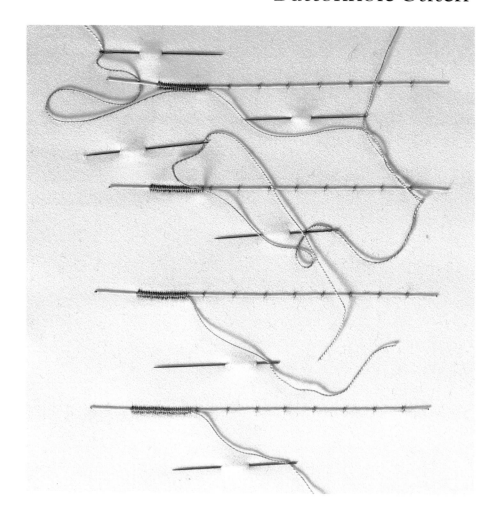

Some people get confused about joining in a new thread to their buttonhole stitch edging. It is fine to finish off the old thread and then bring the new thread up through the last loop of the buttonhole stitch. The only problem is that sometimes the loop breaks or loosens, giving you a bump on your edge.

This is the way that I change threads. (I have worked in two different colour threads to easily identify the old and new threads.)

1. Park the old thread to one side and bring up the new thread where you would be working your next stitch.

2. Park the new thread at the top of your hoop and work one last stitch with the old thread. This stitch locks around the new thread.

3. Park the new thread down at the base of your hoop, and take the old thread down to the back over the top of the new thread and secure at the back. Continue to work with your new thread.

Gaps in Buttonhole Edgings

Gaps in their buttonhole edgings worry some people, and so they like to colour the wire in a complementing shade.

I prefer not to colour the wire, as if you are working, for example, with black thread over black wire on black fabric, you will not be

able to see what you are doing. If the wire is left white, it is easier to make your buttonhole stitches side by side.

Having said this, some people's eyesight just won't permit them to embroider the buttonhole stitches side by side and they get gaps. There is a way to correct this – making your buttonhole stitch look perfect.

While you are working the split backstitch inside the buttonhole edge, as you work up to a white speck of wire, take the needle from the inside of the wire shape down over the wire but inside the pearl edge of the buttonhole stitch. In this way it is like a couching stitch that disappears into the buttonhole. You do need to make sure, though, that the stitch is inside the pearl edge of the buttonhole. If it is not, you may cut it when cutting out the leaf or petal.

When working long and short buttonhole stitch, this correcting stitch is not a little couching stitch – it will come up from within the petal or from the vein of a leaf and then go down over the wire but inside the pearl edge once your petal or leaf is complete. With this stitch, however, you need to remember to darn in the thread on the back so there are no long threads hanging on the back.

Waste Knots

A waste knot is a useful tool in embroidery. There are two ways to use them.

The first is to make the knot on the surface of the embroidery a sufficient distance away from where you are stitching so that after completion of the area you are working on, you can cut the knot and darn in the long thread on the reverse of your work.

knot

The second is to make the knot on the surface of the embroidery close to where you are working and then make two small split backstitches inside an area to be worked. You can then cut off the knot and continue to embroider – the two small stitches will be enough to hold your thread.

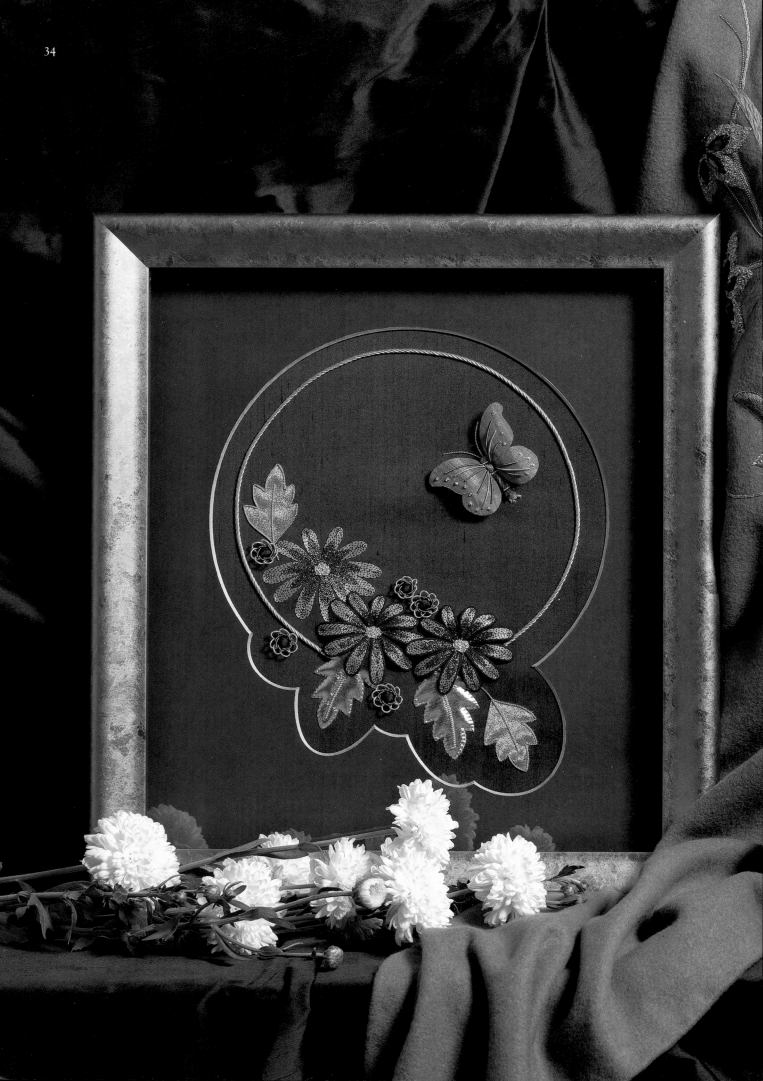

Projects

A special note to those working the following designs – all embroidery throughout this book uses one strand of thread in a #10 crewel needle unless stated otherwise. When using Gütermann thread remember to run it through wax before use.

Throughout the project instructions, rather than repeat instructions for a particular technique, a cross-reference given to a previous page which provides the relevant information.

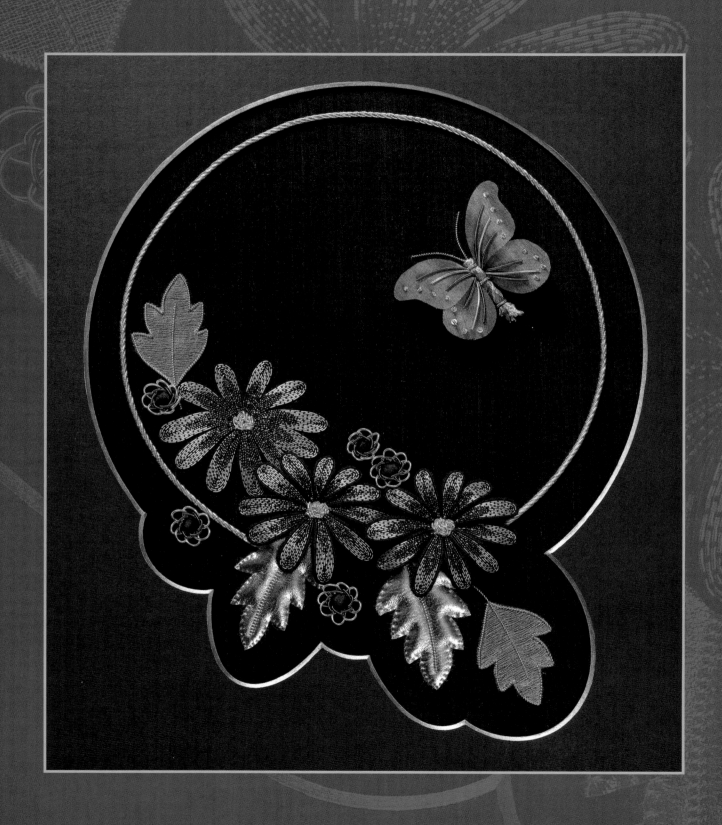

Oriental Odyssey

Oriental Odyssey

REQUIREMENTS

35 cm x 30 cm plum silk dupion

10 cm square plum silk dupion

2 x 22 cm squares of burgundy homespun

10 cm x 7 cm gold metallic organza

14 cm x 5.5 cm yellow felt

13 cm x 5 cm gold kid

10 cm x 12 cm fine (80) woven brass mesh

65 cm gilt 4 ply Bright Gimp

50 cm Super Pearl Purl

20 cm Pearl Purl #2

1.5 m Smooth Purl #6

1 m Golden Threads Purple Purl

12 m Smooth Passing Thread #6

Kreinik Silk Mori ® (2.5m skeins): 4 skeins 1098 Wood Rose

Thread Gatherer Silk: 1 skein Plum Honey

20 x # 18 paillettes

Gütermann Polyester Thread #968

11 x 30 gauge white cake wires

#10 crewel needles

#18 chenille needles

51 cm tapestry frame with 38 cm side bars

15 cm hoop

Design size: 20 cm x 25 cm

Apply the large piece of plum silk dupion to the frame [see page 2] and transfer the base design onto your background fabric using dressmaker's carbon [see page 16].

Begin by couching the 4 ply gimp around the circle shape using waxed Gütermann thread; start off with three or four stitches to secure leaving a tail of gimp inside the kid leaf shape. Couch on the diagonal, laying the thread in the grooves of the gimp, about every fourth groove. At each end of the circle, separate the strands of the gimp and stitch down as flat as possible inside the leaf shape.

Padding with Felt

Cut out the felt shapes from the pattern sheet in yellow felt. For both the leaves and the flowers, the smaller pieces of felt are applied first, followed by the larger ones [see page 17].

Applying Kid

Cut out the kid leaves, remembering to cut slightly larger than the pattern to accommodate the felt padding. Apply the kid over the padding [see page 22].

The veins on the kid leaves are worked in stretched Pearl Purl #2 [see page 6].
To apply pearl purl over the top of kid, you need to consider what happens if you bring your needle up in the wrong place: you will have a hole that cannot be hidden.

The way around this is to bring your needle up slowly and not break the surface of the kid. You will see a small mound from the point of the needle: drag your needle (and thus the mound) until it is in the correct position and then break through the surface of the kid.

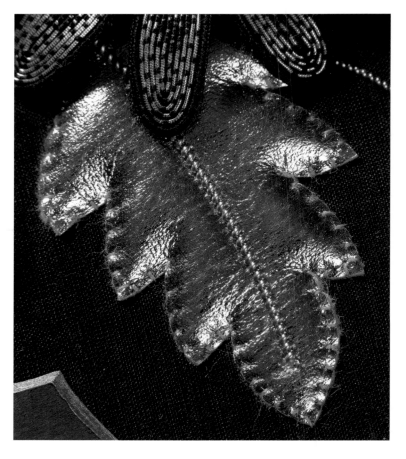

Organza Leaves

The organza leaves are applied with tiny split backstitches all around the leaf shape. Remember that the smaller the stitches, the more they are doing. Lay the organza over the leaf outlines and stitch – if you have trouble seeing through the organza, cut a template out of GLAD Bake ® and hold in place with a few catching stitches over the top (being careful to line the template up with the base design). You can thus easily work the split backstitch around the template shape. The organza is then cut away as close to the split backstitching as possible. Stretched Super Pearl Purl is stitched over the backstitching to hide your stitching and further strengthen the application in the same manner as the pearl purl was applied to the kid leaves.

Flat Petals

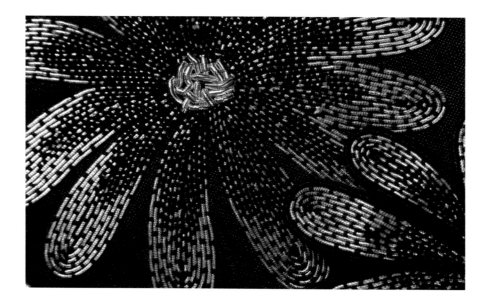

Using one strand of Kreinik Silk Mori ® 1098, couch Smooth Passing Thread #6 around the edge of each petal (on the design outline), with stitches about 4 mm apart. Go back to the beginning and add extra couching stitches as desired to shade.

Shade the petal Or Nué style – more couching stitches at the base, less at the tip.

For the second and all subsequent rows, work the shading/couching as you go. When you have finished filling the shape take the ends through to the back using a #18 chenille needle and secure to the calico on the back of your work.

For each row after the first, bring your needle up on the inside of the shape and take it down on an angle underneath the previous row to make sure that the smooth passing thread is lying as close to each other as possible without overlapping.

Detached Petals

Place one piece of the burgundy homespun into the 15-cm hoop and tighten until drum tight. Transfer the detached petal shapes onto the homespun with dressmaker's carbon as per your base design.

Couch a half length of wire to each petal shape using one strand of Kreinik Silk Mori ® 1098 in a #10 crewel needle, beginning with a waste knot – you should only need 7- 9 stitches. Note that on most petals the wires do not touch – leave a long tail of wire on each side of the base of the petal to take through to the back of your work.

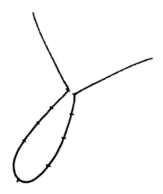

Next, work a row of buttonhole stitch over the wire – covering it completely. Hint: Begin with a single chain stitch and then work in buttonhole stitch [see page 30].

Couch Smooth Passing Thread #6 around the inside of each petal, bringing the needle up a thread's width away and taking the needle down on an angle beside the buttonhole edge. Shade the petal Or Nué style the same as the flat petals. When finished, take the ends of smooth passing thread through to the back with a #18 chenille needle and secure.

Cut out the detached petals close to the buttonhole edge and rub your fingernail along the edge to fluff up any hairy bits to re-trim.

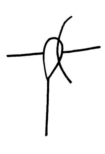

To apply the detached pieces to your embroidery, place a #18 chenille needle through the base design until the eye is halfway through the fabric and holding open a hole in the fabric. Slide the wire tail through the hole and secure on the back of your work. To be extra secure, oversew your wires to the calico on the back, bend your wires in a U shape and oversew again. Do not cut off any wires until all of your petals have been applied and you are happy with their placement.

Once the detached petals have been applied, you can work the flower centres. The centres are chips of Smooth Purl #6 applied with Gütermann thread, approximately 3-5 mm in length and placed randomly to cover the felt [see page 26].

Button Flowers

Cut out five circles of silk from the 10 cm square of silk, using the shape on the pattern sheet as a guide.

Run a gathering thread around the circle approximately 3 mm in from the edge using Gütermann thread #968. Cut up some small scraps of silk fabric and use to stuff the 'button', pull up the gathering stitches and secure. Sew the button over the top of the circles marked on the base embroidery using ladder stitch (that is, a stitch through the button, a stitch through the background fabric and pull gently to tighten [see page 27]).

Around each button apply hoops of Purple Purl overlapping from inside to outside with each application. Outside the row of Purple Purl hoops, place a row of gold Smooth Purl #6 hoops – again overlapping the purls. Each purl should be cut to exactly the same length.

The approximate length of the purple purls will be 10-12 mm. The approximate length of the gold purls will be 14-18 mm.

Note: do not pull the thread too tight or the purls will crack and be mis-shapen.

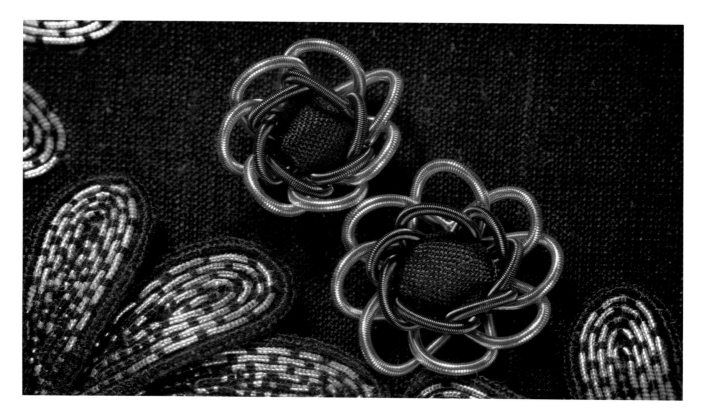

Butterfly

Place the brass mesh over the pattern and trace the wing shapes onto the mesh with a pencil. Cut out with old scissors.

Stitch the wing embroidery next, working from the wing base to the tip for the first stitch, then tip to base for the next and so on in order to to minimise the thread on the back of the wing. Check out the diagram.

To apply the spangles, bring the needle up through the mesh, thread on the spangle, thread on a chip of smooth purl, and go back down through the spangle and the mesh.

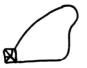

Apply the wings to the base embroidery beginning with the lower wings. Stitch through the tab on the wing to join onto the base embroidery.

Fold the Plum Honey silk into eight lengths 10 cm long, and using Gütermann thread and starting at the head of the butterfly, couch through the loops to secure. Twist the eight threads to make a rope and place a couching stitch at the base of the head (top of the wings), another at the base of the wings (making a body), and two more at the base of the tail. Secure the couching thread but do not cut it off – use it to apply a piece of Smooth Purl #6 over the couching stitches.

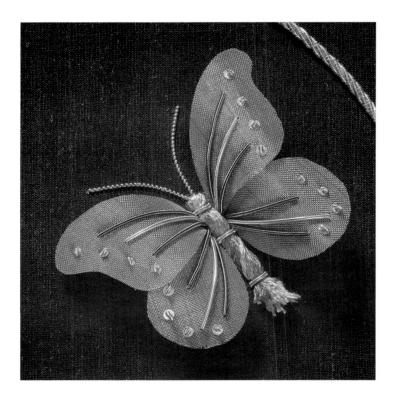

Trim the silk that is left hanging from the tail of the butterfly to different lengths and tease with a needle or brush up with a comb.

The antennae are couched Super Pearl Purl.

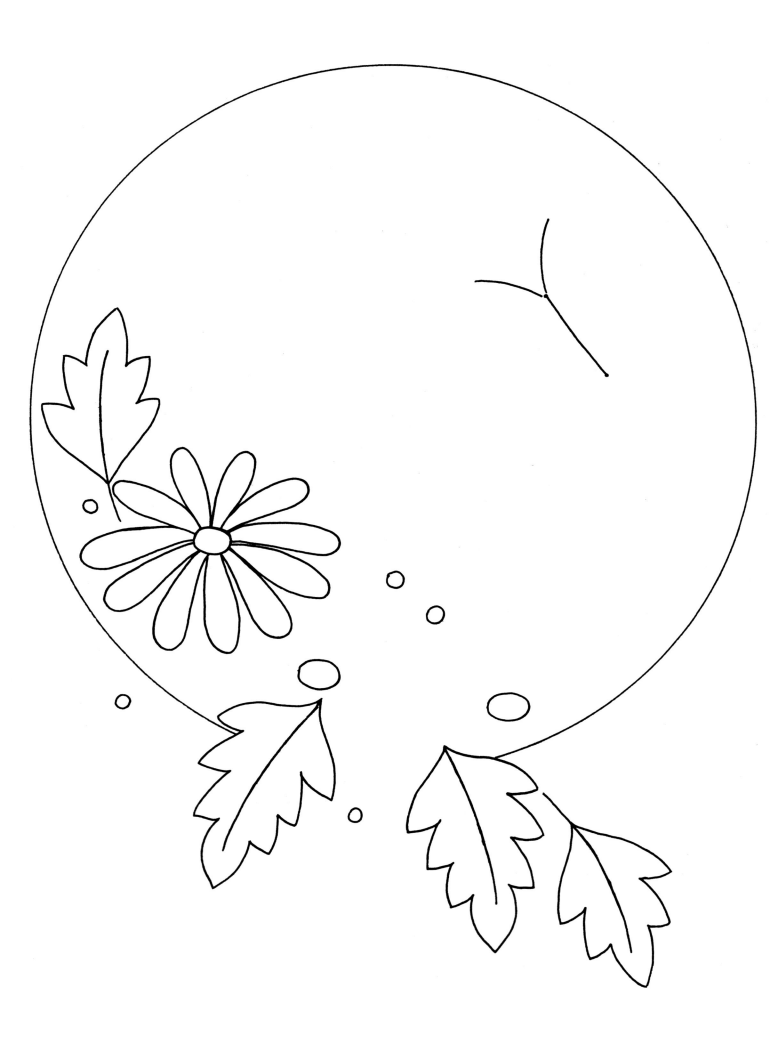

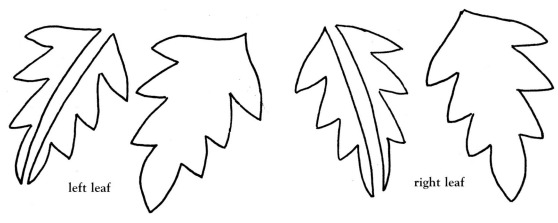

left leaf right leaf

felt shapes

flower centres
detached
flowers

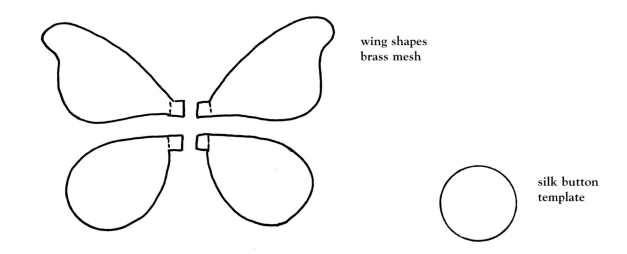

wing shapes
brass mesh

silk button
template

detached petals

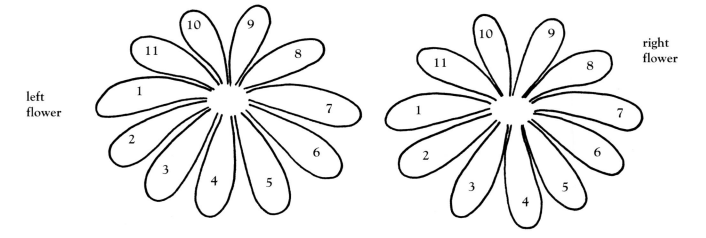

left
flower

right
flower

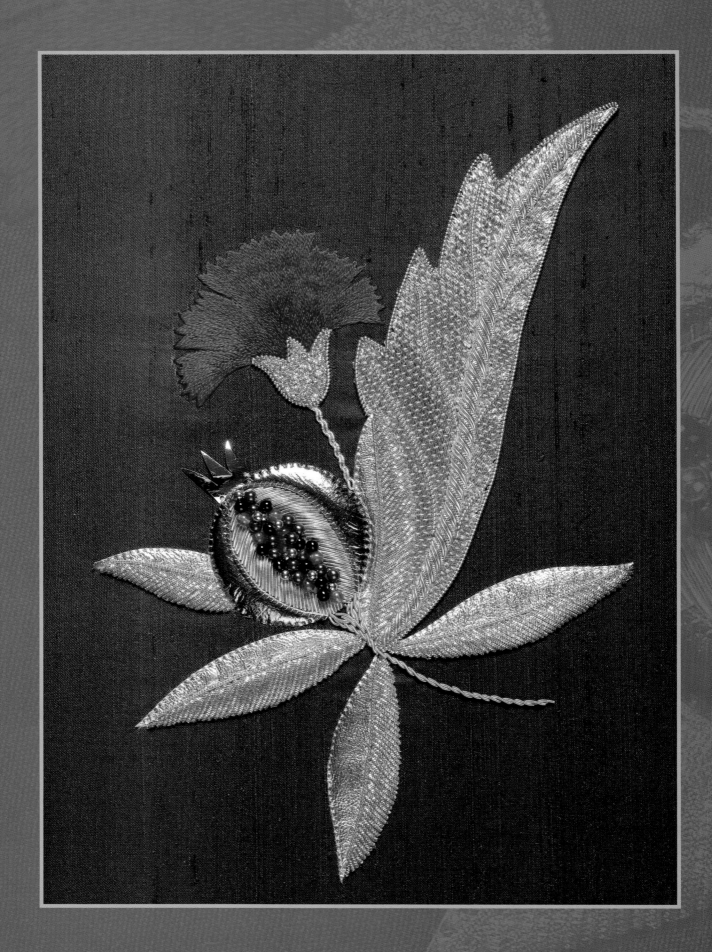

In Memory of Morris

In Memory of Morris

REQUIREMENTS

28 cm x 33 cm purple shot silk dupion

10 cm x 24 cm golden yellow felt

10 cm x 7 cm gold kid

5 cm x 6 cm copper hogskin

DMC Soft Tapestry Cotton: 1 skein 2726

Au Ver à Soie Silk: 1 skein each 944, 946

2.3 m Smooth Purl #6

1.6 m Rough Purl #6

5 m Bright Check Purl #6

50 cm Pearl Purl #1

50 cm Pearl Purl #2

25 cm Gilt Milliary Wire

15 cm Fine Rococco

Cotton On Creations Gold Couching Thread #614: 1 pkt

Gütermann Polyester or Silk Thread #968

20 x 4 mm dark red beads

20 x 4 mm copper red beads

20 x 4 mm orange beads

20 x 3 mm gold beads

2 large gold sequins

#7 & #10 crewel needles

18 chenille needle

#10 beading needle

46 cm tapestry frame

Design size: 17 cm x 25 cm

Apply the silk dupion to the prepared frame and transfer the design using yellow dressmaker's carbon [see pages 2, 16].

Felt Padding

Cut out of yellow felt the portion of the leaves marked with a F, the calyx of the carnation and two pieces of felt for the pomegranate fruit – one is the outline on the pattern sheet, the second piece as per the following diagram.

Apply the felt for the leaves and calyx – the smaller piece is applied first for the pomegranate – centred within the fruit design [see page 17].

actual size

Padding with Cotton

Cut three metres of soft cotton into twelve 25-cm lengths and run them through wax [see page 18].

Lay along the line of the vein and couch the twelve strands down together, beginning halfway up the length of the vein. Remember to couch firmly but no `sausages'! Work down the vein, when you are 4 cm away from the base, prune out some lengths of soft cotton. When you reach the base of the vein you should have five lengths left – couch tightly to end. Work up the vein, and when you are about 6 cm away from the tip, prune out threads again, leaving five threads remaining at the tip. Couch the end down tightly again and trim off the excess threads from either end.

Couched Acanthus Leaf

If you wish, you can mark the directions to couch in on the leaf using a fabric pencil or tailor's chalk. Couch using Cotton on Creations Couching Thread #614 in brick stitch, starting at the base of the leaf, beside the pomegranate leaf [see page 20]. Your first row should run alongside your felt. When you get to the other side of the leaf, turn 180 degrees and couch the thread alongside the previous row.

When couching on the right-hand side of the leaf – begin at the base on the outside – the first row should be about 5.5cms long.

Do not worry if you have a slightly jagged edge to the leaf where the turnings are – these will be covered with Pearl Purl #2.

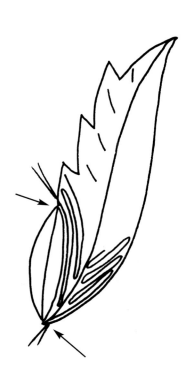

To take the tails through to the back of your work, thread them through the eye of a #18 chenille needle and pull firmly. Secure the tails to the calico at the back with Gütermann thread.

Carnation Flower

The carnation flower is worked in long and short stitch (read the hints and tips on long and short stitch [see page 27]). Work the background petals first (petals 2 and 5), outline with split backstitch and be aware of your stitch direction. The split backstitch and first rows of long and short are embroidered in Au Ver à Soie 944, the base of the flower is worked in 946.

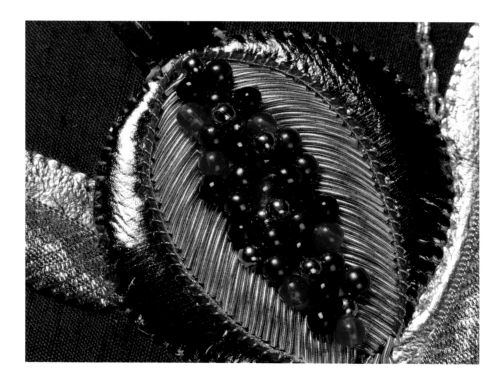

Kid/Hogskin

The pomegranate leaves that are not covered in felt have gold kid applied to them. Remember, do not tape the pattern to the front of the kid, tape it to the back with the right side of the pattern facing the wrong side of the kid [see page 22].

Cut out of copper hogskin the outside pieces of the pomegranate fruit and apply over the felt padding.

Laying Purls over Felt

Mark with a pencil the centre lines of the pomegranate. Either side of the area to be beaded (between the kid) will be covered with Smooth Purl #6. Cut the purls to length and sew on like bugle beads, laying them side by side on an angle . Remember that when working with purls over padding, they need to be slightly longer than if they were on the flat silk [see page 25].

You will find it easier to get a nice angle if you start in the middle and get your angle right first, then work in both directions. If the purl is cut too long, it will sit up like a bubble – but do not cut it smaller as this longer piece may fit somewhere else in the work. Instead remove the purl and cut a smaller piece.

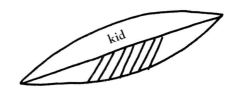

The leaves of the pomegranate are worked in the same way using bright check purl.

Acanthus Vein – Purls over Cotton

The vein of the acanthus leaf is a repeating pattern of two pieces of Smooth Purl #6 and one Bright Check Purl #6 laid on an angle to cover the cotton padding. As with the leaves and pomegranate centre, start away from the base of the stem to get the angle happening and then work in both directions.

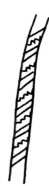

Finishing the Pomegranate

Couch Milliary Wire over the join between the kid and the smooth purls, starting at the base, working to the tip and then back to the base. Thread up a crewel needle with two strands of Au Ver à Soie 944 and come up from the back at the base and thread through the Milliary Wire loops. Take to the back and end off.

Cut a sequin to shape for the crown of the fruit and punch small holes in it with a pin. Stitch to the tip of the pomegranate.

Stitch beads randomly in the space between the smooth purls.

Pomegranate Leaves

The veins of the pomegranate leaves are stretched Pearl Purl #1, couched with waxed Gütermann thread [see page 6].

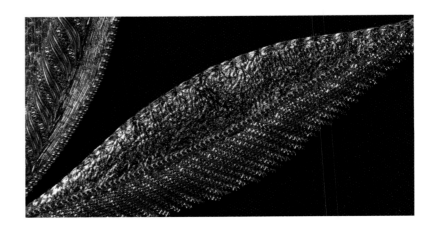

Carnation Calyx

The calyx is outlined with stretched Pearl Purl #2 starting at the central tip.

The felt is covered with small chips of Bright Check Purl #6 [see page 26]. Cut the pieces to approximately 3 mm in length and place randomly over the felt shape. They can overlap, curl around and go in any direction. The more directions they face, the more the work will sparkle.

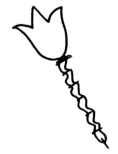

Couch Rococco between the carnation and the pomegranate for the stem. Start by doubling the Rococco and couching the loop at the base of the stem. Then couch each of the crinkles together, finishing with a double couching at the end. Cut the Rococco close to the calyx or take the ends to the back and secure.

Pomegranate Stem

The stem is worked in a technique called 's'ing. 'S'ing is stem stitch – but threading on a purl with each stitch and sliding it down so that the previous purl overlaps. The new purl is brought down to the fabric before the thread of the previous purl has been completely tightened. In this way the new purl ends up underneath the previous one. Work in this way from the base to the fruit and work rows of 's'ing to fill in the V shape at the base of the fruit.

Acanthus Leaf Outline and Smaller Veins

Stretch Pearl Purl #2 and couch outline around the leaf. Stitch it just inside the outside row of the couching so that the pearl purl is balancing on the edge. The veins of the leaf are also Pearl Purl #2.

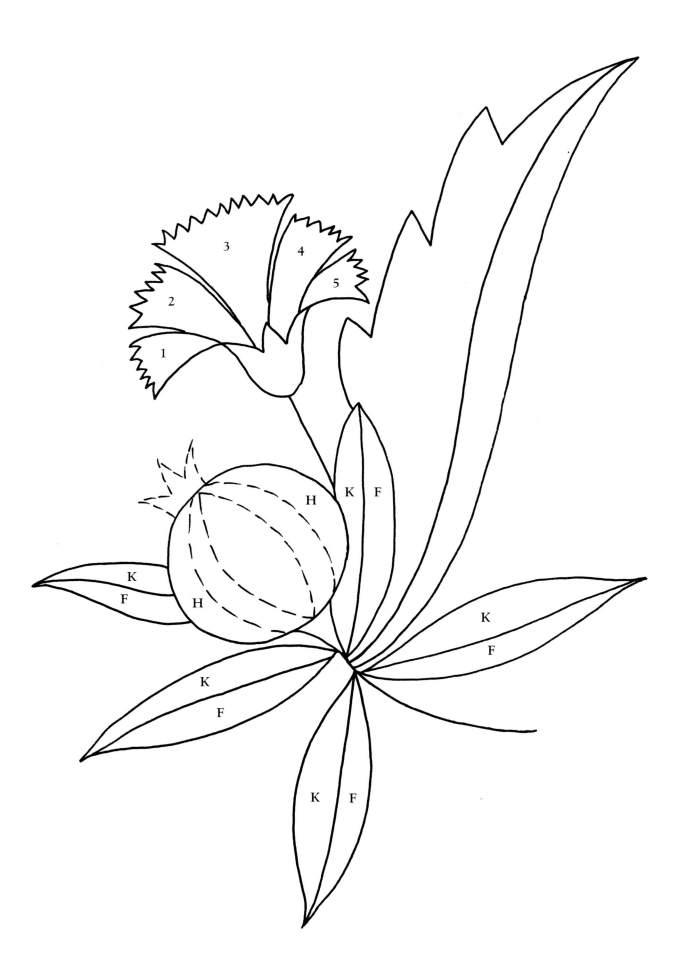

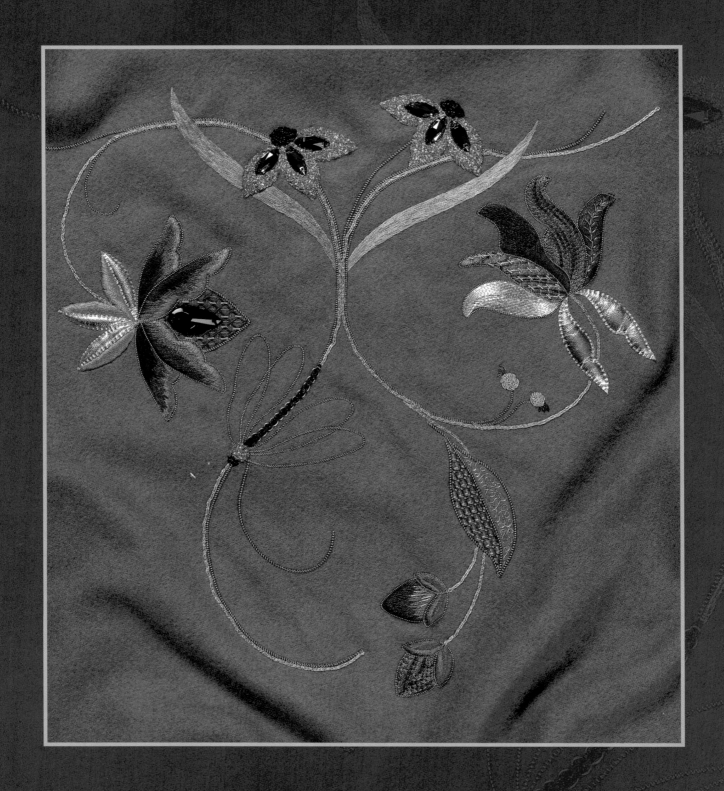

Jacobean Elegance

Jacobean Elegance

REQUIREMENTS

150 cm Peruvian Violet Charming Creations Wool Blend Fabric

150 cm silk habutai for lining

7 cm x 7 cm gold kid

10 cm x 20 cm beige felt

10 cm x 8 cm yellow felt

3 m 3 Ply Twist – gold

150 cm Super Pearl Purl

80 cm Pearl Purl #1

90 cm Pearl Purl #2

50 cm Rough Purl #6

2.5m Bright Check Purl #6

1 m Smooth Passing Thread #6

Cotton On Creations Gold Couching Thread 608: 1 pkt

18 mm x 8 mm Navette Glass Imitation Stones: 6 amethyst

27 mm x 14 mm Teardrop Glass Imitation Stones: 1 amethyst

Frosty Rays: 1 card Y351

Colour Streams Silken Strands: 1 skein Saltbush

Colour Streams Ophir Silk: 1 skein Berry

Au Ver à Soie Silk: 1 skein each 4245, 4634, 4635, 4636

Anchor Lamé Thread: 1 skein 303

Caron Impressions: 1 skein each 101, 5000, 5002, 5004, 6021, 6022

Gütermann Polyester or Silk Thread #968

Gütermann Polyester Thread #128

Mettler Polyester Thread 0741

Machine Embroidery #40 Rayon – neutral shade

#3 & #10 crewel needles

#18 chenille needles

White frog closure

Purple dye

56 cm tapestry frame with 36 cm side-bars

Plastic set square

Design size: 35 cm x 35 cm

Apply calico to frame in usual manner and mark centre of calico [see page 2]. Cut fabric in half on the diagonal to give a large triangle shape for shawl and mark centre of the triangle. The design is placed a minimum of 7 cm down from the raw edge. Lay the triangle over the frame – accommodating the design area – and apply to the frame with herringbone stitch using #40 machine rayon. (Rayon is used so that when the thread is removed there are no stitching marks.) Apply the design using the tack tracing method [see page 17].

Stems

Fold a length of 3 Ply Twist in half to double and couch using Gütermann thread. Couch through the loop and begin at the flower on the left side, working around and down to the dragonfly tail. Where the stem is overlapped by stems and a flower, take through to the back with a chenille needle, re-emerge and continue couching.

Continue left stem from base working up to the dragonfly.

Begin the right stem at the tip of the tendril and work around to the flower.

Embroider the remaining stems on the right-hand side working up from the buds next.

Felt

Cut out the felt shapes to apply. The iris flowers and centres, the berries, dragonfly body and head pieces and petal 1 of the right flower are cut from yellow felt; all remaining shapes are cut from beige felt.

Position the felt shapes as per the pattern sheet and apply, couching at the extremities and then all around 2-3 mm apart [see page 17].

Place and stitch the iris flower felt down and then apply the smaller flower centre over the top. The dragonfly has the smaller piece of felt applied to its body first and then the larger piece.

For the buds at the base of the design: lay the smaller piece of felt first, followed by the larger shape and finally the calyx shape.

yellow felt pieces
berries, dragonfly head and dragonfly
body (actual size)

berries

head

body

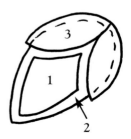

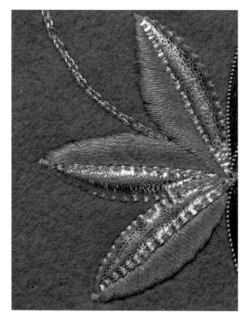

Kid

The leaves at the base of the right flower are applied kid, as is half of each leaf behind the left flower. Refer to the photograph. Cut out the kid shapes and apply over the felt padding [see page 22].

Iris Leaves

Using Colour Streams Silken Strands Saltbush, work in long and short stitch beginning at the tip and working towards the base [see page 27].

Left Flower

The remaining half of each leaf behind the flower are worked in satin stitch using Au Ver à Soie 4245.

The petals are worked in long and short stitch using Au Ver à Soie 4634, 4635 and 4636. On this fabric (and because there is an edge applied to the flower), there is no need to outline first with split backstitch. Work along the edge of the centre petals first in the lightest colour (4634), working in the next darkest shade for each subsequent row.

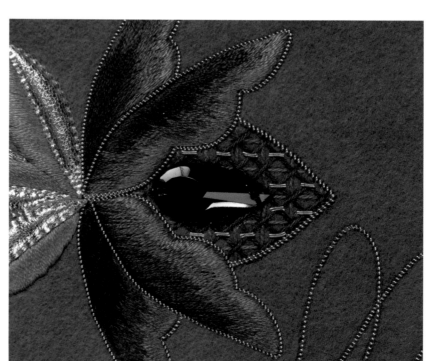

Using Caron Impressions 6022 and a #3 crewel needle, lay horizontal and vertical parallel lines over the centre of the flower. Hint: Using a plastic set square enables you to line up the first stitch with the marking on the square, giving you a precise distance between your stitches.

Using Caron Impressions 6021, lay diagonal parallel lines over the top of the existing trellis, crossing the junctions of the 6022.

Using a doubled waxed length of Mettler 0741, apply the teardrop stone in the middle of the flower centre with two stitches in the base hole and four stitches in the top hole.

Place a chip of Rough Purl #6 over each junction of 6021 that lies in the centre of a square of 6022.

Outline the flower petals with stretched Super Pearl Purl and the flower centre with stretched Pearl Purl #2 [see page 6].

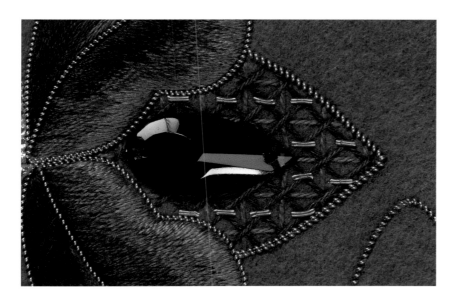

Right Flower

The first petal of this flower is worked in couching using Cotton on Creations 608, waxed Gütermann thread and using brick stitch [see page 20]. Begin at the base of the petal on the outside edge (remembering to leave tails of thread to take through to the back), work upwards to the tip, turn and follow the edge of the petal to where it touches the second petal. End off the couching thread as you started. Continue with successive rows until the shape is filled.

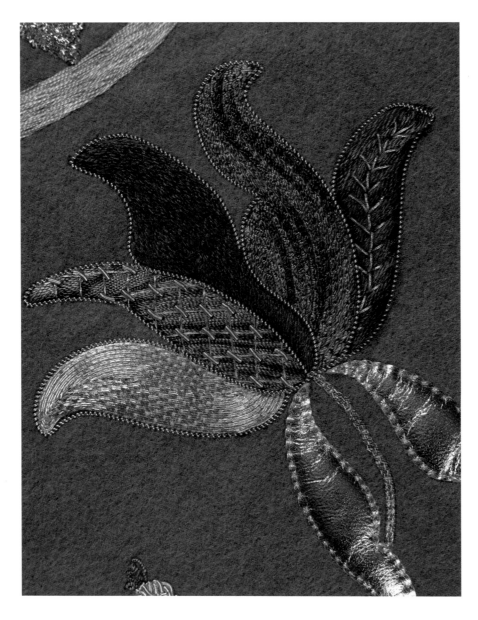

Petal 2 is worked using Colour Streams Ophir Silk Berry in a #3 crewel needle in satin stitch laid on the diagonal.

Work trellis over the top of the satin stitch using two strands of Anchor Lamé thread 303. Embroider the first layer of the trellis in the opposite direction to which the satin stitch is worked, otherwise the stitches will sink into the satin stitch. The second layer is embroidered at right angles to the first layer of stitching.

Over each intersection of thread, place a chip of Rough Purl #6.

The third petal is worked in long and short stitch using Caron Impressions 6021, again in a #3 crewel needle. Begin at the tip and work towards the base of the petal.

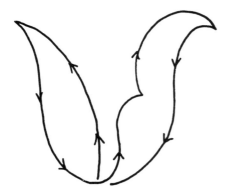

The fourth petal is rows of chain stitch, beginning at the tip and working down the right side of the petal, using Colour Streams Ophir Silk Berry in a #3 crewel needle.

Petal 5 is worked in satin stitch worked on the diagonal using Caron Impressions Cherry 101 in a #3 crewel needle. Next, work fern stitch over the top using Smooth Passing Thread #6 in a #18 chenille needle.

Outline the second and fourth petals first with Super Pearl Purl: begin at the base of Petal 2 on the right-hand side, work up to the tip, down to the base and then continue up the left side of Petal 4 to the tip and back to the base. Outline the remaining petals in any order.

Lower Leaf

The left side of the leaf is worked in battlemented couching. Lay parallel stitches/lines of Caron Impressions 5004 vertically and then horizontally. Once the first rows are down the rest is easy!

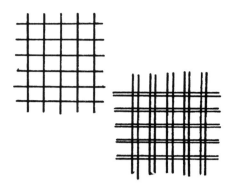

Lay stitches/lines of Caron 5002 right beside the first vertical stitches on the right-hand side (like satin stitch but in a different colour), and then the horizontal stitches below the first stitches in the same manner.

Lay a third series of stitches/lines using Caron 5000, again to the right side of the vertical stitches and below the horizontal stitches.

Work a tiny tie-down stitch using Caron 5004 over the intersecting stitches worked in Caron 5000.

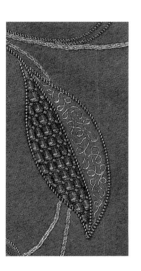

The right side of the leaf is worked in cornelli work using a single length of Cotton on Creations 608 couching thread couched with waxed Gütermann thread.

The leaf vein/stem is embroidered next in Pearl Purl #2 and then the leaf shape is outlined in the same thread.

Buds

The top bud is worked in long and short stitch using Caron Impressions 6021 and 6022 in a #3 crewel needle. Highlights of Anchor Lamé thread 303 (two strands) are added next.

The lower bud is worked in rows of chain stitch using Colour Streams Ophir Silk Berry in a #3 crewel needle, starting at the outside edge and working to the tip for all rows.

The bud leaves/calyx are worked in closed fly stitch from the tip to the base of the leaf. Lay a single thread first in the centre, then work fly stitch with the tiniest tie-down stitch using Caron Impressions 5002, again in a #3 crewel needle.

Outline the calyx and then the bud using stretched Super Pearl Purl.

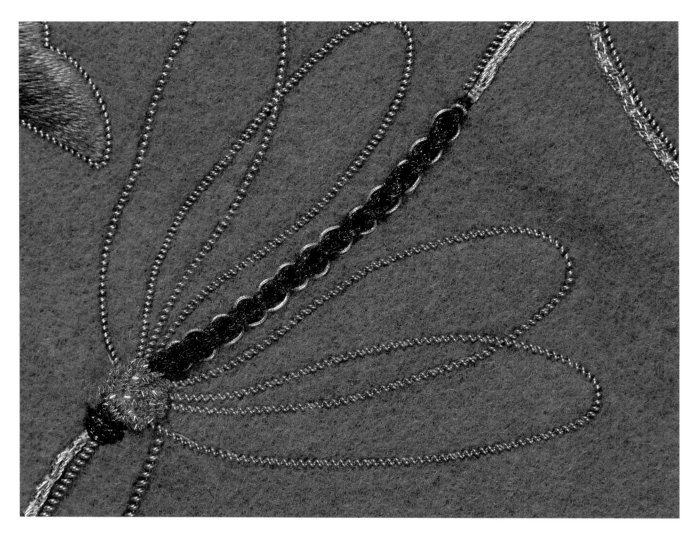

Dragonfly

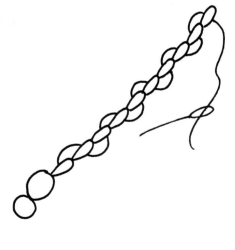

The tail of the dragonfly is worked in laced chain stitch. Work the tail in chain stitch from the body to the tail tip using Frosty Rays Y351 in a #18 chenille needle.

Thread up a length of Smooth Passing Thread #6 in the same needle and lace from the body to the tail tip and back again to the body.

The head is embroidered in Frosty Rays Y351 in satin stitch, still using the #18 chenille needle.

Apply chipping to the body using Bright Check Purl #6 [see page 26].

The dragonfly's wings are Pearl Purl #1 – apply the back wings first so that the front wings overlap. Don't forget to place a couching stitch on either side of the overlapping so that the purl doesn't sit up.

Iris Flowers

Using a doubled waxed length of Mettler 0741, apply the Navette stones to the centre of the iris petals with two stitches per hole.

Fill the remainder of the petal shapes with chipping using Bright Check Purl #6 cut to 3-5 mm lengths.

Fill the flower centres with one wrap French knots of Frosty Rays Y351 in a #18 chenille needle.

Tendrils, Stems and Outlining

Stretch Pearl Purl #2 for the upper tendrils on the left and right sides and apply running it along the 3 Ply Twist until you hit the V where the stems meet.

Apply stretched Pearl Purl #1 for the lower tendril on the left side, bringing it around until it meets the dragonfly's tail. On the right side stem, apply Pearl Purl #1 from the base of the right iris flower all around until it becomes the stem of the first berry. Apply second berry stem.

The stem of the right iris is applied next in Pearl Purl #2, running down to the V.

From the dragonfly down, the stem has Pearl Purl #2 running along the inside edge. Pearl Purl #2 is also the tendril under the dragonfly.

Berries

The berries are worked in chipping using Rough Purl #6. Three small chain stitches in Colour Streams Ophir Silk Berry finish the berries.

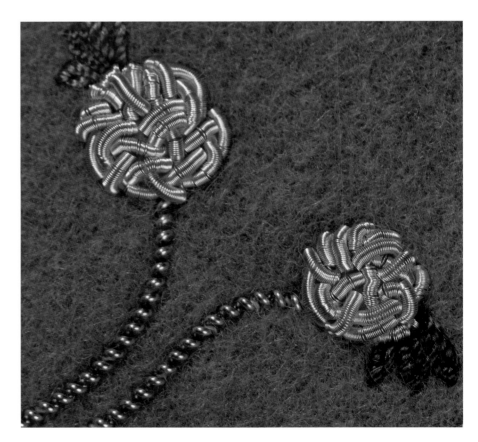

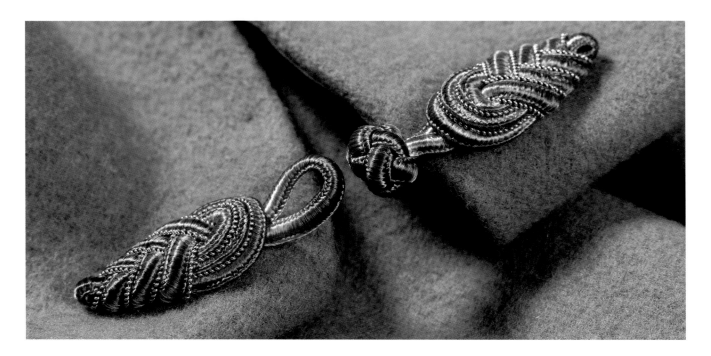

Embroidering the Frog Closure

The frog closure is first dyed with purple/plum tones to complement the shawl fabric. It is then embroidered with Super Pearl Purl along the joining lines of the braid that makes up the closure.

Embroider two rows on the rounded curve of the frog first, balancing on the joins of the three rows of braid.

Next, work the plaited area of the frog. Edge each side, starting on the front and working around the back of the frog, back to the front.

To make up the shawl/wrap, cut the lining silk habutai fabric on the cross the same as the wool blend fabric. Pin the silk to the wool with the right sides together and machine stitch with a 1-cm seam allowance using Gütermann polyester thread #128 and leaving a 25-30 cm opening where marked.

Turn the shawl through to the right side and press the seams. Ladder stitch the opening closed and then edge stitch the shawl by hand with tiny slip stitches, again using the Gütermann polyester thread #128.

Stitch the frog closure to the completed shawl at a height/position to suit the wearer. On the sample the closure is located 57-cm above the lower front points of the shawl.

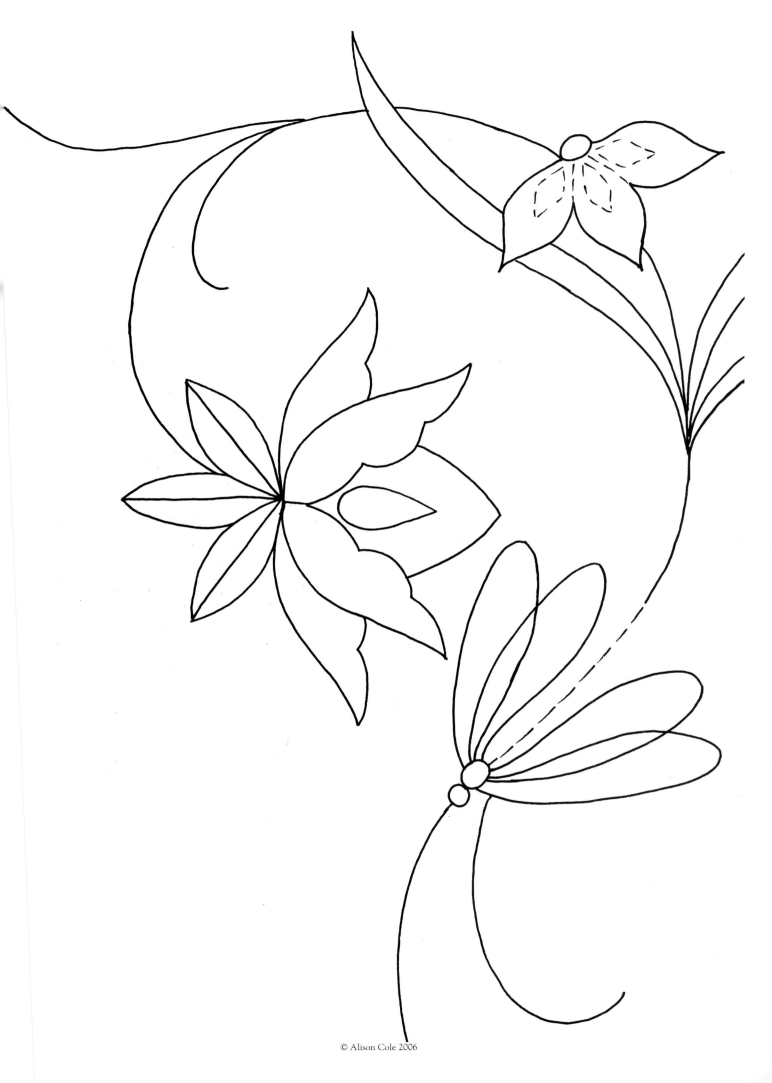

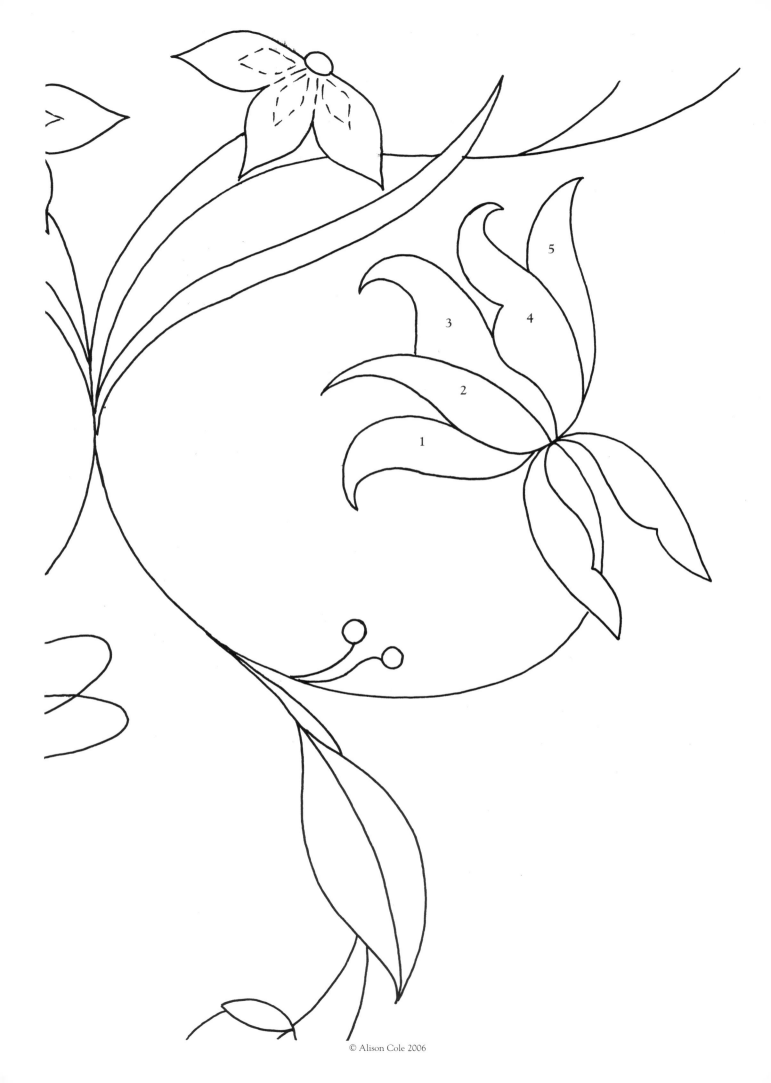

© Alison Cole 2006

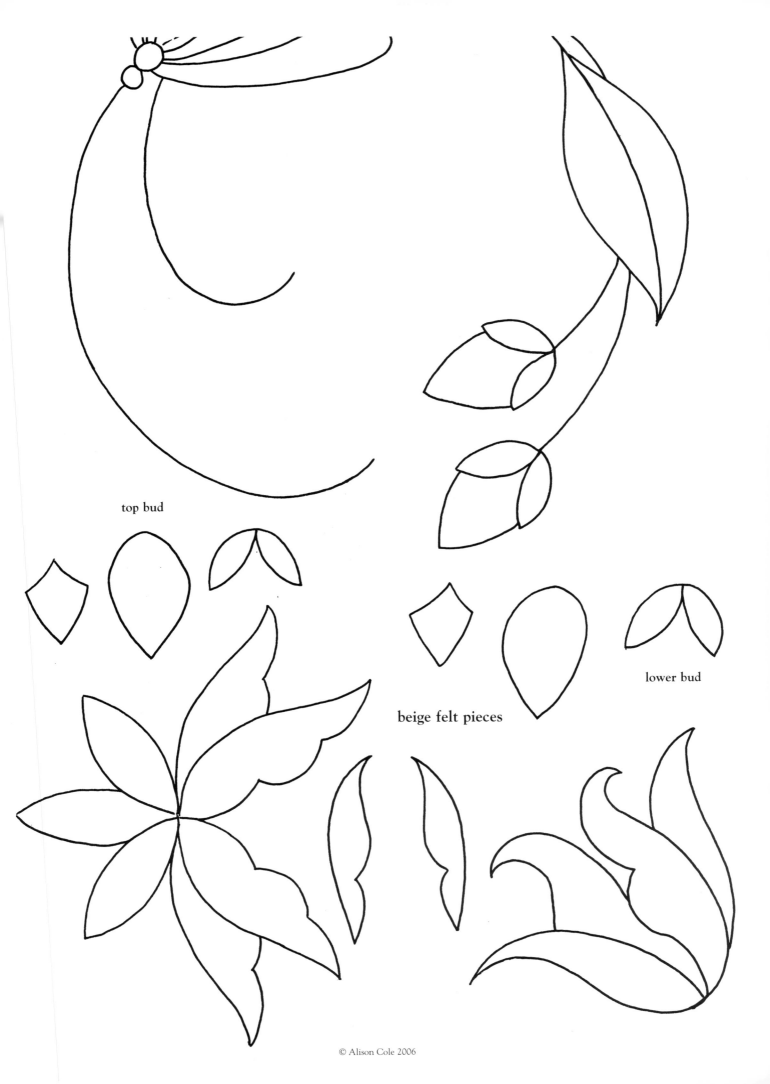

top bud

beige felt pieces

lower bud

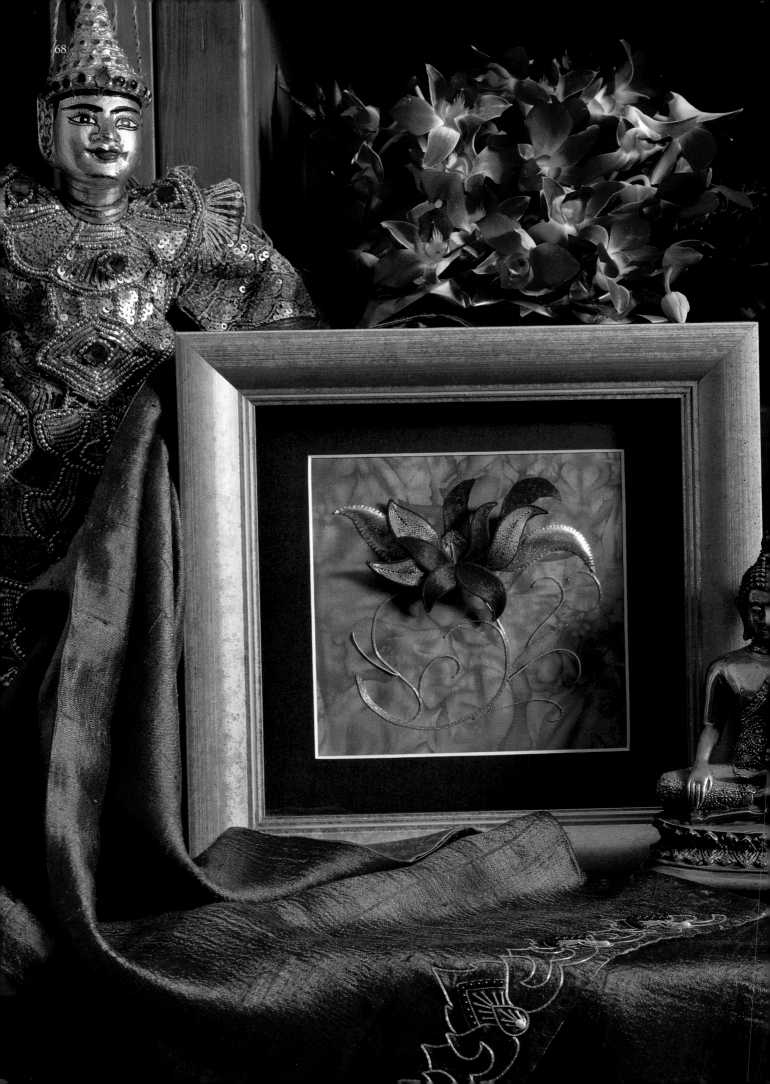

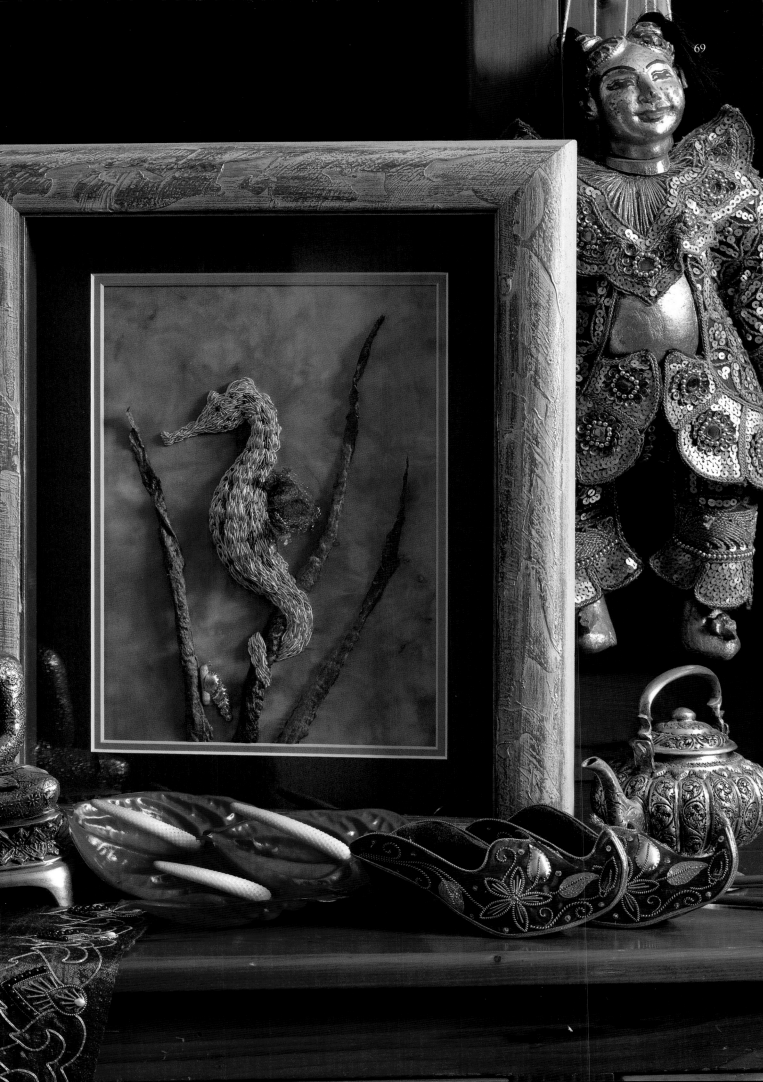

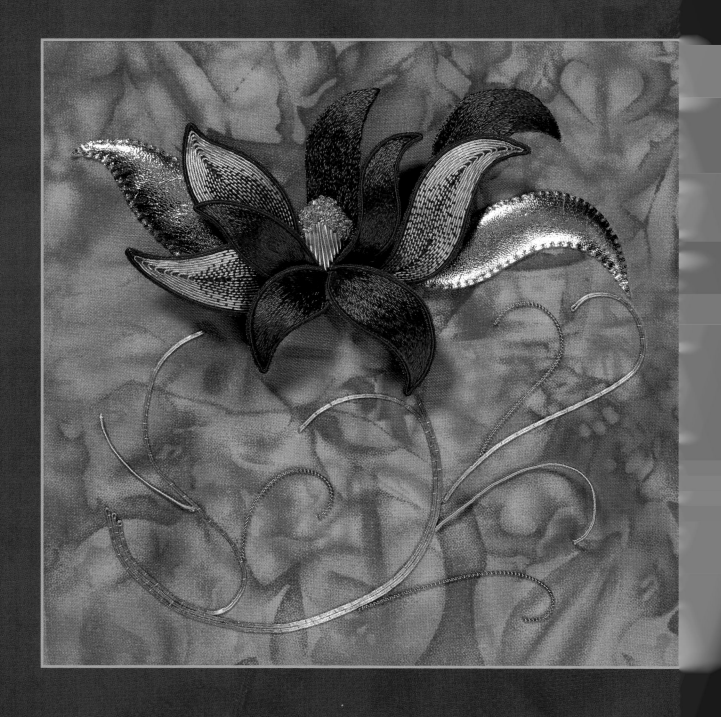

Golden Lotus

Golden Lotus

REQUIREMENTS

36 cm square aqua/turquoise cotton fabric

36 cm square quilter's muslin

22 cm square red homespun

6 cm x 10 cm yellow felt

7 cm x 7 cm gold kid

4 x 30 gauge cake wires

Rajmahal Art Silk: 2 skeins 255, 1 skein 45

Madeira Metallic #3: 1 pkt colour 3

Gütermann Polyester or Silk Thread #968

7 m Smooth Passing Thread #6

30 cm Smooth Purl #6

15 cm Bright Check Purl #6

25 cm Pearl Purl #1

25 cm hoop

15 cm hoop

#3 and #10 crewel needles

#18 chenille needles

Design size: 14 cm x 14 cm

Place the cotton background fabric over the muslin and place in the 25-cm hoop and tighten until drum tight. Transfer the design using white dressmaker's carbon [see page 16].

Padding

Trace and cut out the petal pieces 1 and 4 and the two flower centre shapes from felt.

The felt padding for the petals are a single layer, applied over the base design [see page 17].

For the flower centre, apply the larger diamond-shaped piece of felt and then apply the smaller L-shaped piece over the top of the diamond [see page 17].

Base Petal Embroidery

Outline petals 2 and 3 with split backstitch using Rajmahal #255. Then fill in the petals using long and short stitch [see page 27].

Kid

Petals 1 and 4 have kid applied over the felt padding. Remember to cut out the kid a tiny bit larger than the pattern to accommodate the padding [see page 22].

Stems

Take a length of Smooth Passing Thread #6 and fold in half to double. Stitching on the edge of, but below the line of, the main stem, couch the doubled thread from the base of the stem to the flower centre using Madeira #3. Begin by couching through the loop of thread at the base. End off by making two couching stitches and cutting the passing thread, leaving tails 2.5 cm long to take through to the back with a #18 chenille needle and secure.

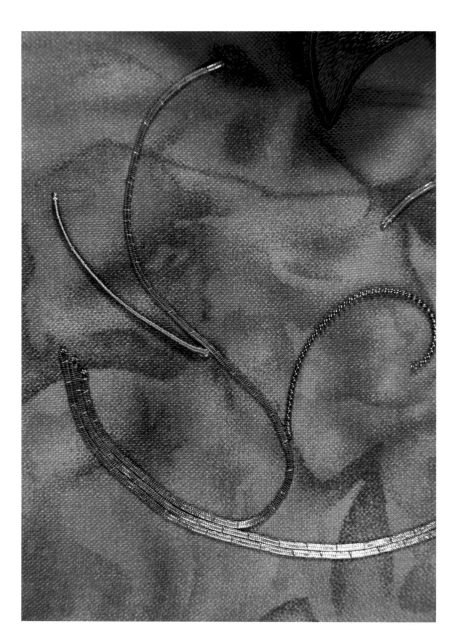

Begin stitching the second row on the inside edge of the first row and couch the loop slightly lower than the first loop, taking this row to the leaf tip using brick stitch [see page 23].

Another row, beginning slightly lower again, and again on the inside, couch in brick stitch to the end of the tendril.

To take the passing thread ends to the back of your work, thread through the eye of a #18 chenille needle and pull the needle through. Stitch the tails to the muslin at the back of your work.

Couching Pearl Purl

The stems to be embroidered in Pearl Purl #1 are marked PP on the pattern sheet.

Stretch the Pearl Purl #1 slightly and apply, couching in the first two coils and then about every third or fourth coil until you get to the end [see page 6].

Wrapped Tendrils

Place 40 cms of Rajmahal #45 (all six strands) into the #3 crewel needle and from the front go into your fabric at the end of the tendril to be wrapped. Come back up to the front again a few fabric threads away and knot the two tails together.

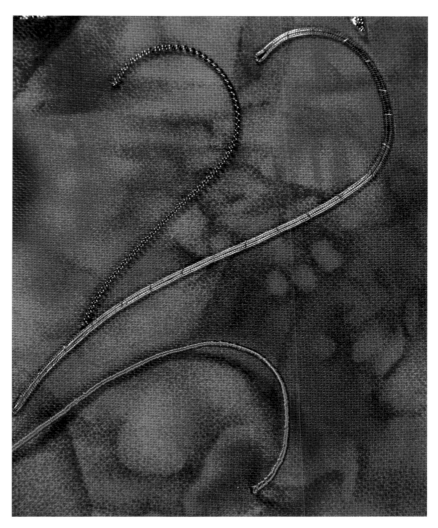

Take 1 m of Rajmahal #45 and ply back to three strands. Put these in a #10 crewel needle and, knotting the end, come up next to the twelve strands that are already planted at the end of the tendril. Carefully wrap the twelve strands with the three strands, using your pointer finger to hold the wraps in place while your thumb and middle finger hold the twelve strands taught.

When you have wrapped the desired length, make a half hitch knot (buttonhole) to hold the wraps in place and take all of the ends through to the back with the #3 crewel needle. (Cut the knot and take the original twelve strands to the back separately.) Use the three strands to secure the twelve strands to the muslin. Before you cut off the remainder of the three strands, cut off two strands and use the single strand to couch the wrapped tendril in place if it is not sitting straight. Repeat the other tendril in the same way.

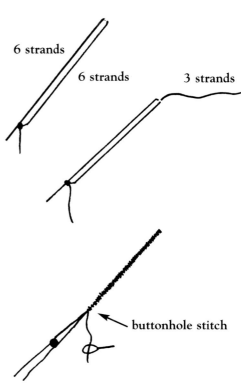

6 strands

6 strands 3 strands

buttonhole stitch

Purls – Flower Centre

Work smooth purl vertically, starting with the longest length in the centre and working outwards, covering the single layer of felt [see page 25].

Next, cut random chips of bright check purl (approximately 3-5 mm long) and apply randomly over the L-shaped double layer of felt. This is called chipping and the more different directions that the purls face, the brighter they will appear to be [see page 26].

Detached Petals

The red petals are labelled a, b, c and d. The Or Nué petals are labelled x, y and z.

Place the red homespun into a 15-cm hoop and make it drum tight. All seven petals need to fit so place reasonably close. Trace the petals onto the homespun using white dressmaker's carbon. Place the petals so that the base of each petal will be facing the edge of the hoop.

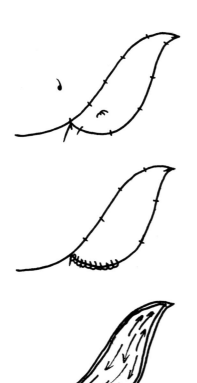

Cut four wires in half to make eight pieces of wire and using one strand of Rajmahal #255, couch in place (begin with a waste knot) [see page 33]. If you wish to colour your wires red do this first, but I find it easier to cover them if they are left white.

Do not cross the wires at the base. Make a couching stitch over both wires so that they sit side by side.

Begin to buttonhole stitch by starting with a chain stitch, and then embroider buttonhole stitch around the shape. The stitches should be touching.

Once buttonholed, work a row of split backstitch around the inside edge of the buttonhole stitch as close in to the edges as possible. This strengthens the fabric so that when you work your long and short stitch the edges don't pull into little holes. The petals are then filled in with long and short stitch in Rajmahal #255, over the split backstitch (but not over the buttonhole stitch). Hint: stitch in the same directions as you worked the flat petals.

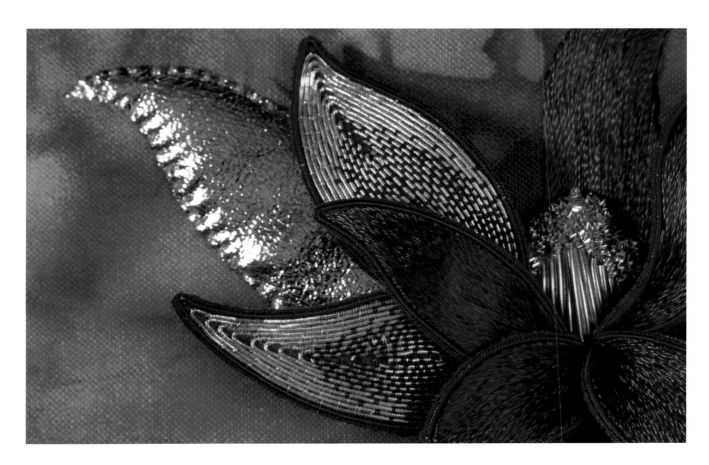

Golden Or Nué Petals

Couch the wire and work the buttonhole edge in the same way as the red petals – but you don't need the split backstitch edging.

In two separate needles, thread up with one strand of Rajmahal #255 and one strand of Madeira #3. Take the Smooth Passing Thread #6 and begin couching the passing thread from the base of the petal leaving a 2.5 cm tail to take through to the back. Or Nué is thread painting with couching stitches. Where you want to make the petal red, couching stitches should be closer together – they can be so close that no gold shows through. Where you want the red to be a shading, – space the stitches apart so that more gold shows through. Where you only want gold on the petal, couch with the Madeira #3.

If you want to mark guidelines on the homespun before you begin, do so with a fabric pencil or tailor's chalk.

Keep working around in a spiral until you get to the centre and the petal is completed. Leave another tail to take through to the back. Take the passing thread ends to the back as before and secure.

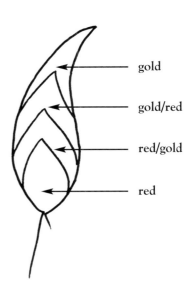

gold

gold/red

red/gold

red

Placing Detached Petals

Carefully, using fine scissors, cut out the petals.

Do not cut any long tails of wire until all petals are placed, sewn down and you are happy with their placement.

Cut the tiny tail ends of wire from the petals, not the long tails. To insert the petals, take the chenille needle and stick through the fabric until the eye is halfway; this holds the fabric open so that the wire can be passed through to the back. The wire does not pass through the eye of the needle, only through the hole that it is holding open.

Place the petals as per the diagram:

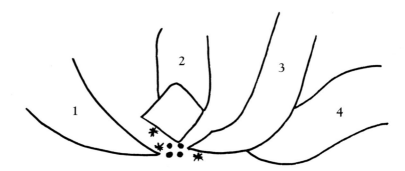

Fold the wire back against the back of the petal and secure to the back of the muslin.

For extra security, fold the wire back on itself (like a U) and stitch again.

Once all of the petals have been attached, shape the petals by stroking the back of them with a chenille needle while holding the tip.

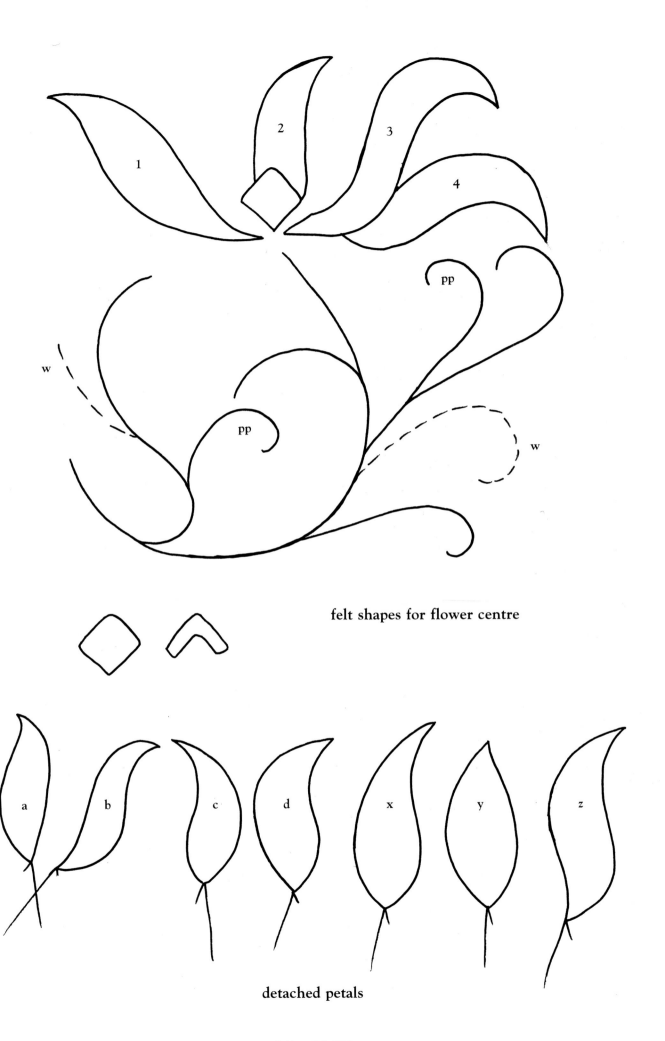

felt shapes for flower centre

detached petals

© Alison Cole 2006

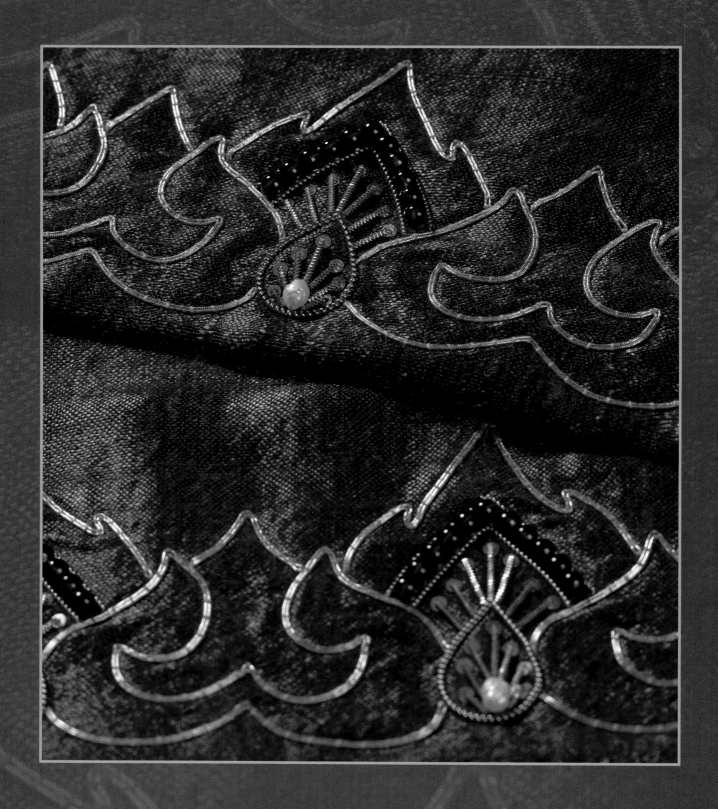

Thai Silk Scarf

Thai Silk Scarf

REQUIREMENTS

2 Thai silk scarves (34 cm x 158 cm approx – one acts as a lining for the other. I have used garnet lined with old gold)

Homespun to match scarf colour

Rayon #40 machine Sewing Thread – neutral colour

10 m Smooth Passing Thread #6

110 cm Bright Check Purl #9

90 cm Super Pearl Purl

40 cm Pearl Purl #1

1g pkt size #18 spangles/paillettes

10 freshwater pearls

100 x 3 mm garnets

Gütermann Polyester or Silk Thread #968

Gütermann Polyester Thread #375

#10 crewel needles

#10 beading needles

#18 chenille needles

46 cm tapestry frame

Design size: 28 cm x 6 cm

Prepare the frame using a matching coloured homespun in place of
the calico, and apply one end of the silk scarf using the #40 machine
rayon. (Using rayon prevents permanent holes in your silk.) Transfer
the design using yellow dressmaker's carbon [see page 16]. Note: If
your scarf has a fringing at the base and you wish to keep it, place
the design 1.25 cm up from the base. If you plan to cut the fringing
off, the design may be placed higher to allow for hemming.

This design is based on a traditional Thai design, the Lotus Bud,
used in architecture, textiles, wood and metal work. The Lotus Bud
motif is also used extensively in India and China and makes
appearances regularly in Egyptian artefacts. Garnets and pearls are
two of the nine stones that the Thai people regard as special.

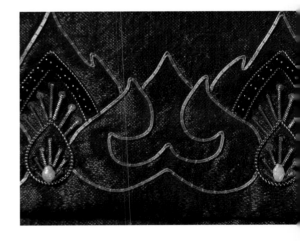

Stretch the Pearl Purl #1 and couch to the teardrop shapes using
waxed Gütermann thread, beginning and ending at the point of the
teardrop [see page 6].

The Smooth Passing Thread #6 is couched doubled. Fold each
length in half and begin by couching through the loop, continue to
the end and take 2.5 cm tails of thread through to the back to
secure. The couching stitches should be 3-4 mm apart – the diagram
below shows where to start couching each motif. Hint: Pinch the
turning points with tweezers to give a sharper point.

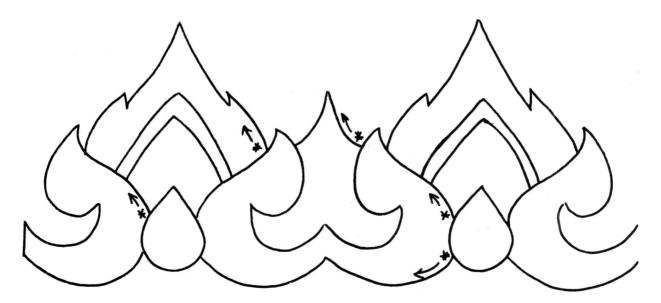

When turning the points – remember to couch the threads down
separately starting with the outside thread [see page 20].

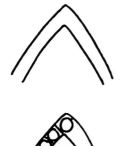

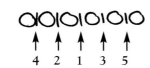

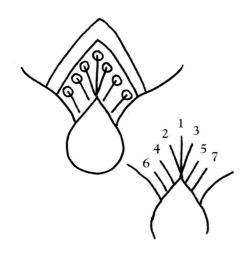

Once the passing thread has been applied, stretch the Super Pearl Purl and couch to the centre of the bud motif.

Using a doubled length of waxed Gütermann thread #375 in a #10 beading needle, apply a string of six garnets to one side of the Super Pearl Purl channel. Place a couching stitch in between each of the garnets to evenly space them in the channel. Hint: When placing the couching stitches, place the first stitch in the centre and work outwards. Repeat for the other side of the channel with five garnets.

In the area underneath the garnets, #18 spangles/paillettes are caught down by seven lengths of Bright Check Purl #9. Begin by applying the central piece and work outwards. Bring the needle up on the top of the point of the teardrop, thread on a length of purl and then the spangle. Take the needle down through to the back of the work and work from side to side.

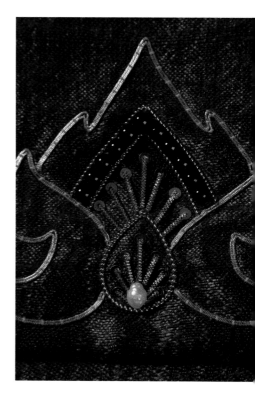

In the teardrop shape apply the freshwater pearl at the base of the shape and then embroider the rays in the same manner as before.

Take the scarf off the frame, leaving a band of homespun behind the design the width of the scarf. If you trim around the design and don't catch the homespun in the side seams it can be noticed.

Frame up again and work the other end of the scarf in the same manner. Machine stitch the two scarves together at the sides, leaving a 1-cm seam allowance. If your scarf had a fringe and you decided to keep it, turn the scarf through to the right sides, press and slip stitch the ends together with very tiny stitches. If you decided not to (or your scarf didn't have a fringe), you can machine stitch one end before turning through, press, then turn a hem and ladder stitch or slip stitch at the remaining end.

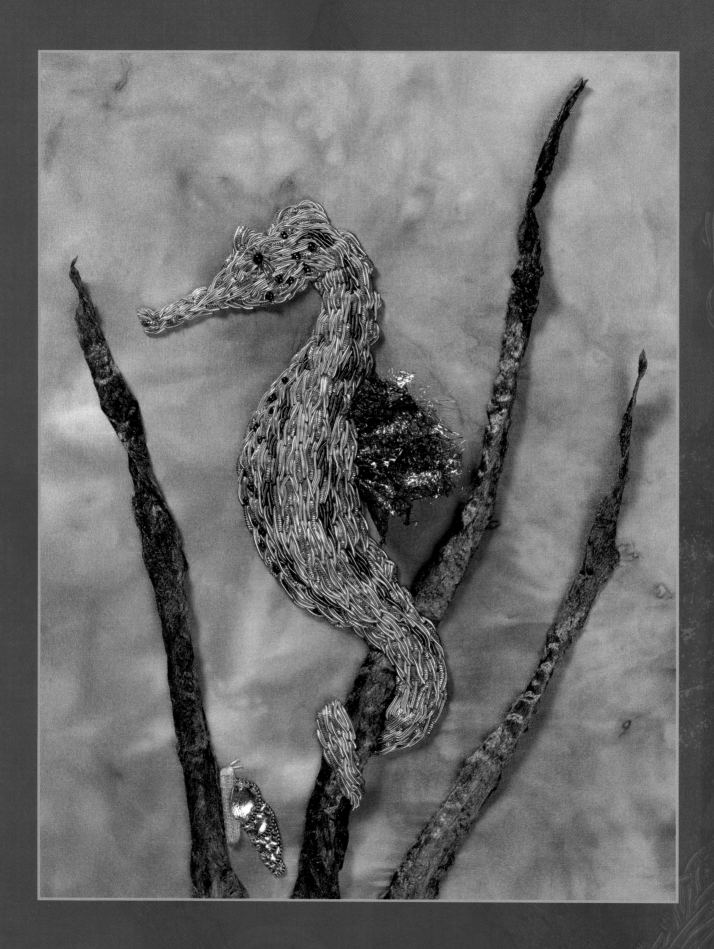

The Seahorse Sentinel

The Seahorse Sentinel

REQUIREMENTS

25 cm x 37 cm hand-dyed silk habutai

16 cm x 10 cm yellow felt

2 cm x 3 cm gold kid

Colour Streams Silken Strands: 1 skein Umbrian Gold

2.5 m Smooth Purl #6

20 cm Smooth Purl #10

2.5 m Rough Purl #6

1.5 m Bright Check Purl #6

40 cm Golden Threads Metallic Blue Purl

40 cm Golden Threads Bottle Green Purl

40 cm Golden Threads Mid Green Purl

10 cm Super Pearl Purl

Gütermann Polyester Thread #585

Gütermann Polyester or Silk Thread #968

DMC Soft Cotton: 1 skein 2726

Tussah Silk Tops – 20 g bag of Machu Picchu

Angelina Fibres – 5 g bag each of Hot Fix Arabian Sky, Gold

Mill Hill ® Seed Beads: 03002, 03035

Jo Sonja's ® Textile Medium

Netting 30 cm x 15 cm

Polyester toy filling

1.5 m cotton twine/ kitchen string

2 x gold 4 mm jump rings

1 x 3 mm black round pearl bead

#10 crewel needles

#18 chenille needles

#28 tapestry needles

48 cm tapestry frame

Fine stuffing fork (or satay stick)

Paint brush

Design size: 16 cm x 24 cm

Apply silk habutai to the frame and transfer the design with dressmaker's carbon [see pages 2, 16].

Silk Seaweed

Hold the Tussah silk fibres in one hand and pull gently with the other hand to break into tufts. Lay the tufts together on a piece of netting to make a length of seaweed (varying the colour placement).

Generally, when making silk paper, you make at least two layers of silk, laying the second layer across the first (at right angles). For this piece it is not necessary to do so.

Sprinkle warm water on the fibres to dampen them and then apply Jo Sonja's ® Textile Medium to the fibres with a paint brush – they should be wet and holding together. Squeeze out any excess medium and lay fibres out in the sun to dry (or dry with a hair dryer). Note: any medium that drips will be coloured by the silk and will be sticky, so place paper towel underneath when drying inside to avoid a mess.

Cotton Padding

Underneath the seaweed is cotton padding. For the left piece of seaweed, take ten lengths of DMC soft cotton 2726 approximately 22 cm long and run through wax until they hold together. Remember to remove the excess wax with your fingernails. Beginning at the base of the seaweed, couch the soft cotton inside the design line. Commence with two or three tight couching stitches, leaving 2.5 cm tails, and then couch every 5 mm firmly but not so tight that the padding looks like a string of sausages [see page 18].

Prune out lengths of soft cotton as you work up the stem to make the stem taper and end off with another two or three tight stitches. Cut off the tails of soft cotton.

The centre seaweed has twenty lengths of soft cotton 22 cm long. The right seaweed has fourteen lengths of soft cotton 17 cm long.

The body of the sea snail is worked in the same manner using six lengths of soft cotton 8 cm long. This time take the ends to the back with a #18 chenille needle and secure.

Sea Snail's Body

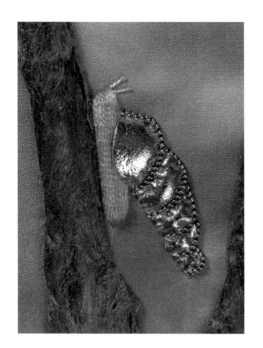

At this stage it is easier to apply the sea snail's body rather than leave it to later. Using the Colour Streams Silken Strands Umbrian Gold, two strands in a #10 crewel needle, make straight stitches across the sea snail's body at 5 mm intervals. Some of these may sit over your couching stitches, while others may not, depending on how even your couching stitches are. You do not want these stitches to be super tight as raised stem band is going to be worked around them, but you don't want them loose either.

With one strand of Umbrian Gold in a #28 tapestry needle, work raised stem band over the laid threads. If you have not done raised stem band before, it is like working stem stitch but going around the laid threads instead of through the fabric. Work from one end of the snail's body to the other, remembering to keep moving the rows of stitches against each other to cover the padding.

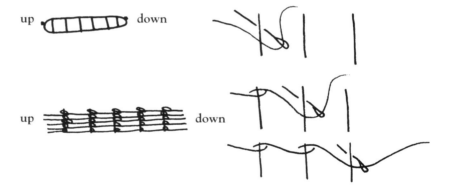

When you have finished, work two pistil stitches for the sea snail's eyes in the same thread.

Applying Silk Seaweed

The silk paper that you have made is applied next. Lay it over the padding and catch in place with tiny stitches on either side – use Gütermann thread #585 and begin at the base. The base of the seaweed need not be fancy as it is going to be covered up with the mount. As you work up the length of seaweed, once the soft cotton padding is covered you can twist the seaweed completely over or twist and catch it on one side, making it sit up.

More Soft Cotton Padding

This time, thread the soft cotton into a #18 chenille needle and build up stitching inside the sea snail's shell area. Stitch each segment of the shell padding separately, building up the stitches higher close to the sea snail and less as you work towards the tip of the shell [see page 18].

Felt Padding

Using your pattern as a guide, cut out the two seahorse pattern pieces in yellow felt. The small tail section may need lengthening depending on the thickness of your seaweed.

Apply the larger piece using Gütermann thread #968 by stitching the extremities, then stitch about 2 cms apart.

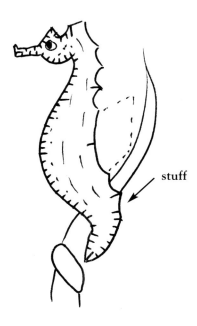

stuff

Next, stitch at 2 mm intervals, beginning at the head and working down around the left side of the seahorse. As you are working up the right side of the seahorse, stuff with polyester toy filling as you stitch the felt. Continue stitching and stuffing until the seahorse felt is applied. Only stuff until the felt is firm – not tight – otherwise it is hard to stitch into. Hint: when stuffing, only use small amounts of filling at a time, otherwise you will get a lumpy effect.

lower tail
section felt
(actual size)

Fin – Angelina Fibres

The fin is made from Angelina fibres. As they are heat bonded work is done between layers of GLAD Bake ® in order not to wreck the iron.

Lay down a piece of GLAD Bake ® and sprinkle with some Arabian Nights Hot Fix fibres. Next add some gold fibres, and finally some more Arabian Nights. Layering is done in this way because the gold does not bond on itself – it needs to be trapped between layers of the Arabian Nights. Place another piece of GLAD Bake ® on top, making a sandwich.

Set your iron to the 'silk' setting and press.

fin pattern (actual size)

side view

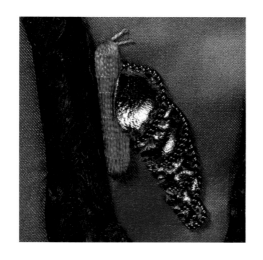

If you want the fin to be lacy, use fewer fibres; for a solid fin, make a dense sandwich.

Using the fin pattern cut out a fin shape from the bonded fibres and run a gathering thread along the seam allowance. Gather and tie off the thread. Stitch the fin to the body, overlapping the seam allowance on the felt.

Note: If you wish, you can either cut out on the edge of the bonded fibres to give a random edge to the fin or you can cut out the fin from the middle and then distress the edge with the tip of your embroidery scissors.

Twine Padding

For each rib on the seahorse, lay three lengths of cotton twine so that the third piece piggybacks the other two (this gives a pyramid shape) [see page 18].

Couch in place with Gütermann thread #968, double couching at the ends and cutting off the excess twine cleanly against the couching stitches.

As the tail narrows, couch only two lengths of twine instead of three.

Sea Snail's Shell

Cut out and apply the five pieces of kid for the shell, using the pattern pieces as a guide [see page 22]. Note: Where the largest piece of kid overlaps the sea snail's body, there are no stitches.

Outline the shell segments with Super Pearl Purl.

Eye Padding

The raised eye of the seahorse is padded with two jump rings. Lay the jump rings one on top of the other and make couching stitches around them to hold them in place (you may need 4 or 5 stitches).

Seahorse

With a pencil or ball-point pen, mark the lines on the seahorse's body. Using Gütermann thread #968, apply a mixture of Mill Hill ® Seed Beads 03002 and 03035 around the cheek area and down the front of the belly.

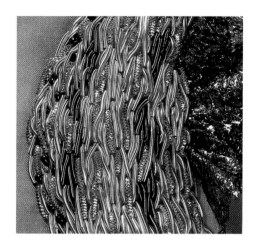

The body of the seahorse is covered with gold and coloured purls, cut to random lengths. Use a mixture of smooth, rough and bright check purls for the gold areas and metallic blue, bottle green and mid-green for the coloured areas.

Apply the purls so that some hang over both sides of the twine padding, while others may start or stop directly on either side of the padding. The idea here is to create texture. Do not apply the purls formally, side by side, but lay them so that some overlap each other as well as the padding.

The purls are applied to cover the felt completely (and the fin seam allowance as well).

The eye of the seahorse is worked in Smooth Purl #10. Work from inside the jump rings outwards with varying lengths. Some of these purls will overlap others that you have laid for the head. In the centre 'well' that is created, stitch a 3 mm black pearl bead.

Hint: Start working in the middle of the belly area and work in both directions. As you work up the neck and head, cut the purls to smaller lengths than those that you used for the body.

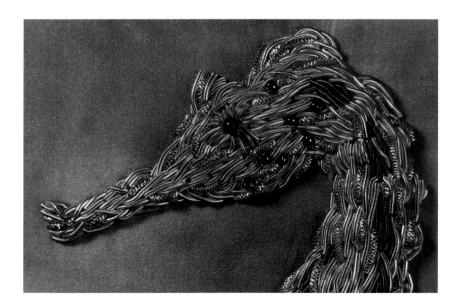

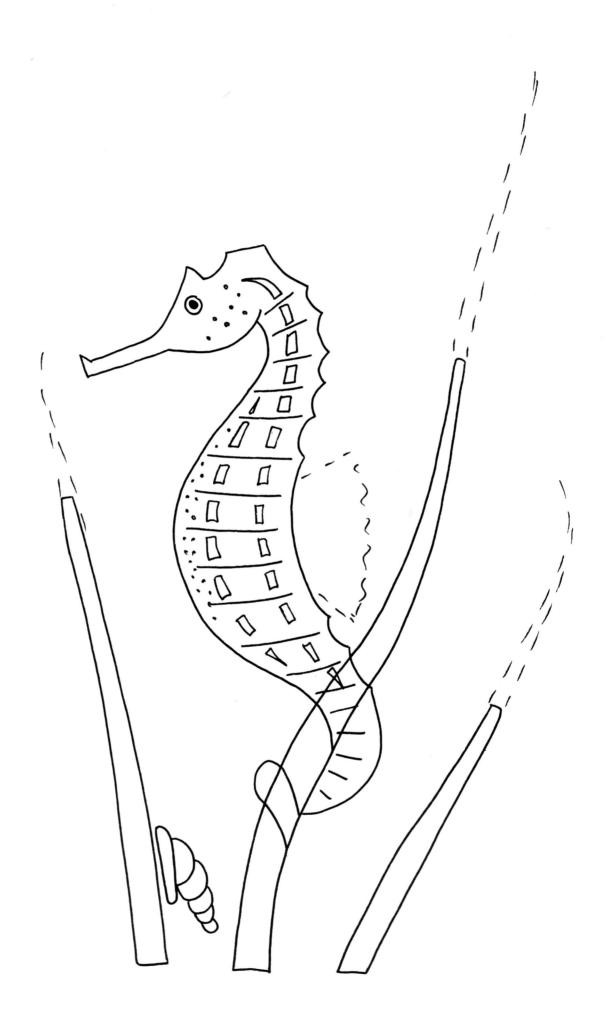

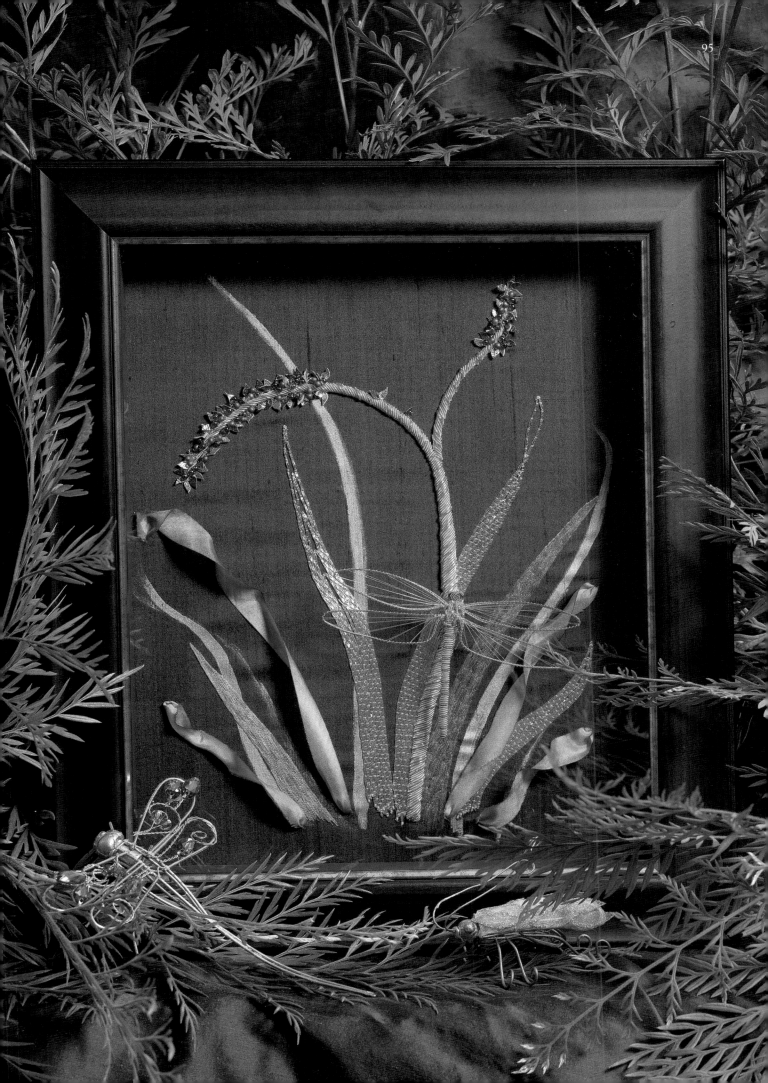

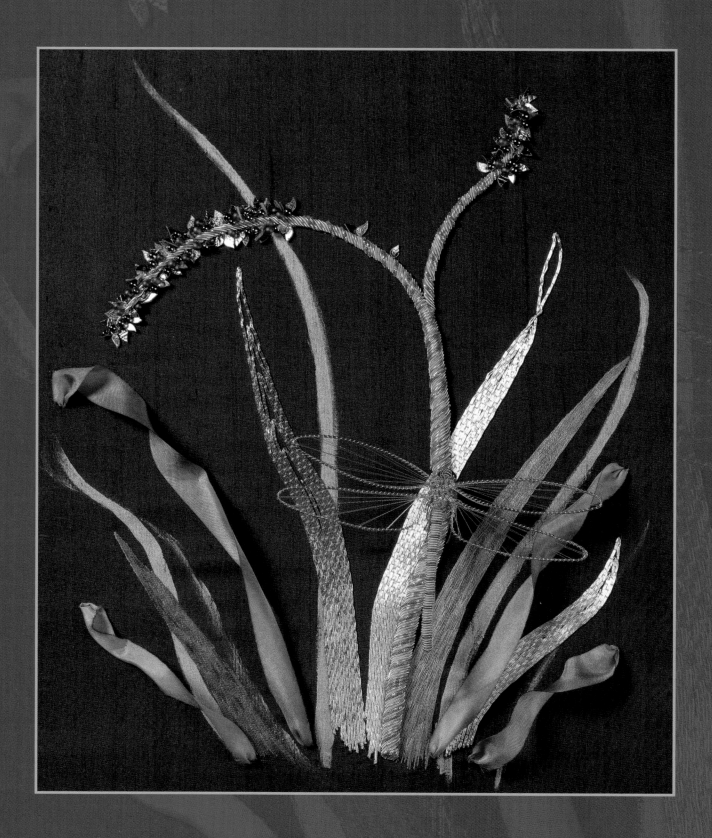

Just Resting

Just Resting

REQUIREMENTS

27 cm x 35 cm brown silk dupion

22 cm x 22 cm gold homespun

5 cm x 5 cm golden yellow felt

5 cm x 5 cm gold kid

5 cm x 5 cm bronze hogskin

1.6 m Smooth Purl #6

1.6 m Bright Check Purl #6

1.8 m Rough Purl #6

30 cm Golden Threads Coppery Brown Purl

70 cm Milliary Wire

Miyuki Drop Beads: 50 x DP134FR & 50 x DP 257

1 skein Colour Streams Silken Strands #29 Russet

2 pkts Cotton On Creations Gold Couching Thread #614

1.5 cm wide Hannah Silk Ribbon Golden Maple: 1.5 m

1 pkt Madeira Metallic #3: colour #3

Gütermann polyester or silk thread #968

DMC Soft Cotton: 1 skein 2726

Plaid ® Folk Art ® Paint: 660 Metallic Pure Gold

24 gauge gold bead wire

#10 crewel needles

#18 & #16 chenille needle

#10 beading needle

51 cm tapestry frame

15 cm hoop

Size 6 round paintbrush

Design size: 17 cm x 15 cm

.

Apply the silk dupion to the frame and transfer the design using dressmaker's carbon [see pages 2, 16].

Painting

I know that it's a dreaded word but some of the background leaves are painted onto the silk using Folk Art ® Metallic Pure Gold paint and a Size 6 round brush. It isn't as hard as it sounds – the foliage that you are painting is simply curved brush-strokes in the background. If you are unsure of how many to place and where to place them, you can refer to the photograph for guidance.

Paint in as many or as few leaves as desired in the background. I have put in three solid leaves and two more that are like shadows – just running the brush out of paint. Hint: do not overload the brush with paint. When you have too much paint on the brush it leaves a raised line on each side of the leaf. You are better off to apply a small amount at a time.

dragonfly wings (actual size)

Dragonfly

Wings (back wing)

Take a 45-cm length of gold #24 gauge bead wire and thread it through the loops of a 14-cm length of gilt Milliary Wire. Centre the Milliary Wire on the bead wire and bend/mould it to the wing shape on the pattern.

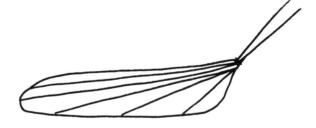

Using a 1-metre length of Madeira #3 (one strand only) in a #10 beading needle, secure the position where the wires meet so that they don't move and then take long stitches up through the loops of the Milliary Wire and back to the base of the wing. Repeat around the wing shape 5-7 times. Secure the thread at the base.

Repeat for the remaining wings. The length of gilt Milliary for the front wings is 13 cms.

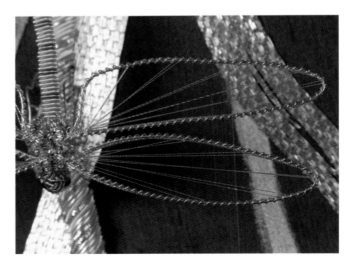

**dragonfly head and tail
(actual size)**

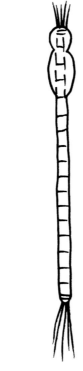

Head/Body/Tail Padding

Place the gold homespun into a 15-cm hoop and transfer the head/body/tail design using pencil carbon [see page 16].

Cut five lengths of soft cotton 13 cm long and run through wax until they hold together. Couch them inside the shape along the entire length from head to tail.

Begin by leaving 2.5-cm tails of soft cotton and placing two or three tight couching stitches at the beginning. Couch at 5 mm intervals until the end and finish off with two or three tight stitches. Cut the tails of soft cotton off flush with the couching stitches. Make sure that the main body of stitches are firm but not tight – you do not want to pull the padding to look like a string of sausages! [see page 18]

Cut out of felt two head/body pieces and a third that is slightly larger. Place the first in place over the soft cotton and apply, bringing your needle up through the fabric and down through the felt [see page 17]. Work two rows of split backstitch around the head and body and then couch the larger piece of felt over the top of the first piece. Keep your stitching inside the split backstitches.

Take the second smaller piece of felt and sew it onto the back of your work, padding the bottom of the dragonfly's head and body. You should be able to place the piece easily due to the split backstitching.

Head/Body/Tail Embroidery

dragonfly eye (actual size)

Lay five rough purls followed by one coppery brown purl, repeating this down the tail over the cotton padding. The purls will all be the same length if your padding is even (except for the tip of the tail) [see page 25] and should all sit neatly side by side. From each side, the purls should touch the homespun and cover the soft cotton.

Cut two small almond shapes from bronze kid and stitch onto the head for eyes. Stitch each piece at each end only (working on the top of the hoop).

Fill the remaining head area with chips of Coppery Brown Purl BUT each time you go through to the back, thread on a Coppery Brown

Purl at the back – so BOTH sides of the head are covered with purl.
Hint: Use slightly larger pieces for the back of the work (the
underneath of the head) as there is a larger area to cover
[see page 26].

Applying Wings

Note: Do not pull the wires too tight when applying the wings or
they will gather.

Using a #18 chenille needle through the centre of the back of the
dragonfly from the top of your work, take the wires through to the
back of your work where marked on the diagram.

Do the following on the back of your work.

Fold one wire from each of the bottom
wings and overcast to the stitching under
the tail.

Overcast the remaining six wires to the
edge of the felt.

Trim off the two tail wires level with the
end of the tail – DO NOT CUT ANY
OTHER WIRES – the remaining wires will
become the dragonfly's legs.

Do the following on the front of your work.

Fold the wings upwards so that they are out
of the way and cover the front and the
back of the felt padding with pieces of
bright check purl.

Cut out around the head and body (where
the split backstitch is) closely – as close to
the split backstitch as you can.

Cut out around the tail leaving a 3-5 mm
seam allowance. Fold the seam allowance
underneath on either side and stitch in
place.

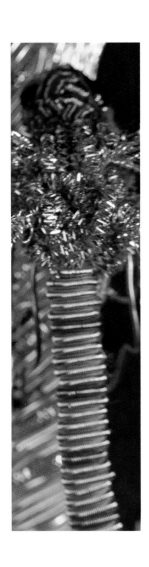

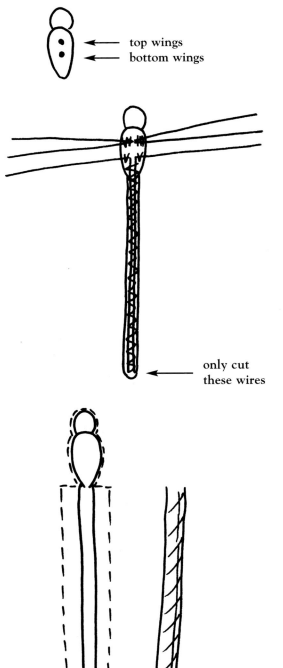

top wings
bottom wings

only cut
these wires

Back to the Base Embroidery
Padding

The main stem is padded with twenty lengths of DMC soft cotton #2726. As for the dragonfly, wax the cotton and begin with two or three tight stitches to begin and couch firmly the length of the main stem starting at the base. To taper the stem, prune out lengths of soft cotton from underneath the main bunch as you work up the stem. The last 2 cm of stem are not padded and when you reach that point you should only have two lengths of soft cotton left.

The smaller right-hand stem is worked in the same way, beginning at the junction and working to the tip.

Couching

When couching in brick stitch, cut two lengths of gold couching thread (Cotton on Creations #614) about 1 – 1.5 metres in length [see page 20].

When outlining or working the first row of brick stitch, you should bring your needle up on the outside of the shape and down on the inside. All subsequent rows come up on the inside of the shape and down on an angle against the previous row.

Make two small couching stitches with Gütermann thread, right beside each other, leaving a 2.5 cm tail of couching thread to take through to the back later.

Couch the length of the leaf with stitches about 4 mm apart. When you get to the tip of the leaf, turn sharply following the leaf outline.

When you get to the base of the leaf, you can either end off the threads leaving 2.5 cm tails of thread to take through to the back and begin again with new threads or you can turn 180 degrees and continue working. The sample has ended off at the base, allowing you to stagger the base of the leaf. Remember to couch the remainder of the leaf in brick stitch.

Silk Shading /Long and Short Stitch Leaves

Using one strand of Colour Streams Silken Strands Russet, outline the tip of the leaf first (about 2.5 cm each side) with split backstitch.

Work the first row of long and short stitch from within the leaf, working up and over the split backstitch edge. For all subsequent rows, bring the needle up through the existing stitching and work down towards the base of the leaf [see page 27]

Laying Purls

The stems are covered with randomly selected smooth, rough and bright check purls (all size 6) laid on an angle. Start about 2.5 cm up from the base of the stem to get a good angle, and then work back towards the base and up to the tip. Note that if the purl is cut too long, it will sit up like a bubble; but do not cut it smaller as this longer piece may fit somewhere else in the work. Instead, remove the purl and cut a smaller piece [see page 25]

The last few stitches are worked without any padding underneath in a technique called 's'ing. 'S'ing is stem stitch but threading on a purl with each stitch and sliding it down so that the previous purl overlaps. The new purl is brought down to the fabric before the thread of the previous purl has been completely tightened. In this way the new purl ends up underneath the previous one. Work in this way to the tip of the stem.

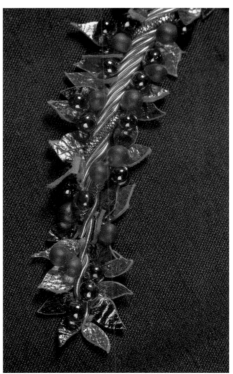

Work the main stem first and remember that when you start the smaller branching-out stem, commence away from its base and work in both directions.

Seeds and Casings

Cut small almond shapes from gold and bronze kid and lots of them! Vary their shape and size. (As a guide, they are close in size to the dragonfly's eyes.)

The seeds are tiny drop beads and the kid casings are only attached with a single stitch at the base. Overlap them, placing single beads under them – you can place some of the kid casings first and then the beads, or beads first and then the kid around them. Sew the beads on

in clusters of two and three at a time and they will sit up like the seed clusters on the plant. Let them overlap the stems to make them look more natural but don't cover up your beautiful stem completely.

Ribbon Leaves

Place an end of ribbon in the chenille needle and take through to the back at the base of the leaf. Knot off on the back. Manipulate the ribbon to where you want it and hold in place with tiny catching stitches of the stranded silk. When the desired length is reached, cut the ribbon and take through to the back, either straight through the fabric or in ribbon stitch (piercing the ribbon with the needle).Secure at the back with stranded silk.

Applying the Dragonfly

Commence by shaping the dragonfly's legs, two face forwards and the remaining four face backwards.

Using the chenille needle, push the needle through the fabric on the edge of the stem until the eye is halfway through the fabric and holding a hole in the fabric open. Pass a leg wire through. Repeat for the remaining legs.

The leg wires should go through the base fabric immediately beside the stem so that the dragonfly looks like it is holding onto the stem.

On the back of the work, oversew the wires to the calico using Gütermann thread. Then twitch the wires together and cut off the excess.

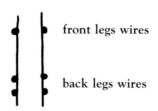

front legs wires

back legs wires

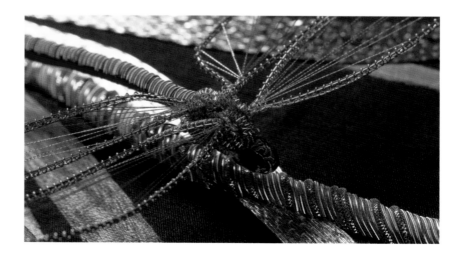

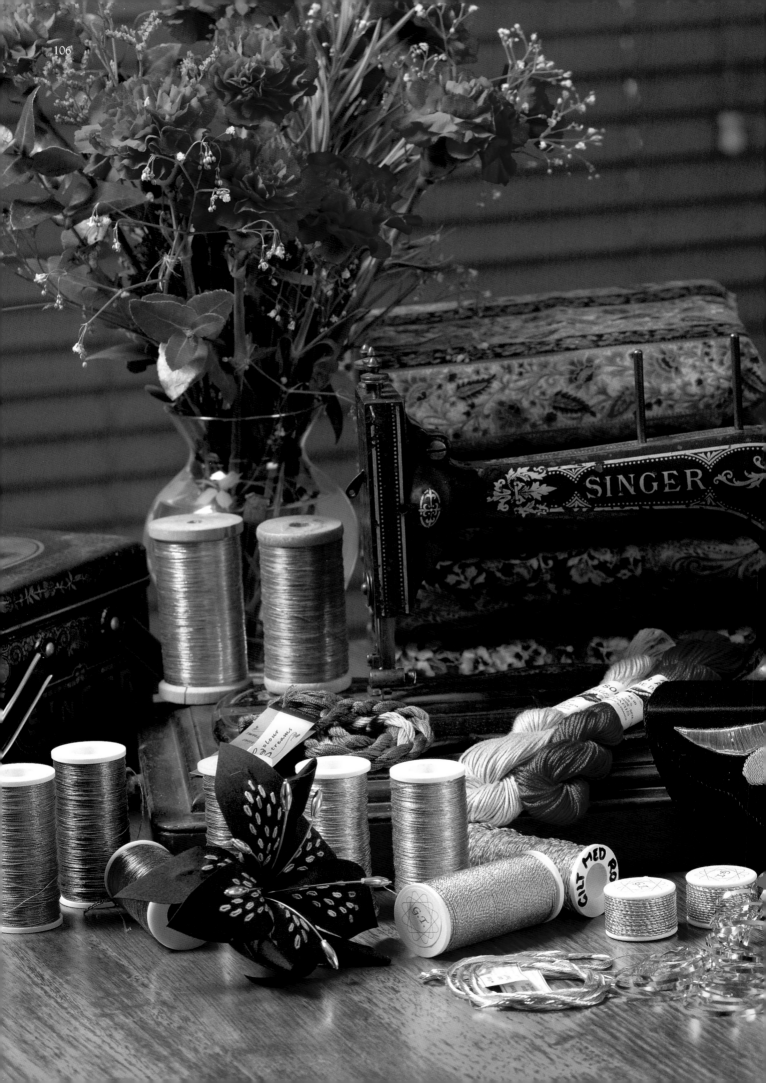

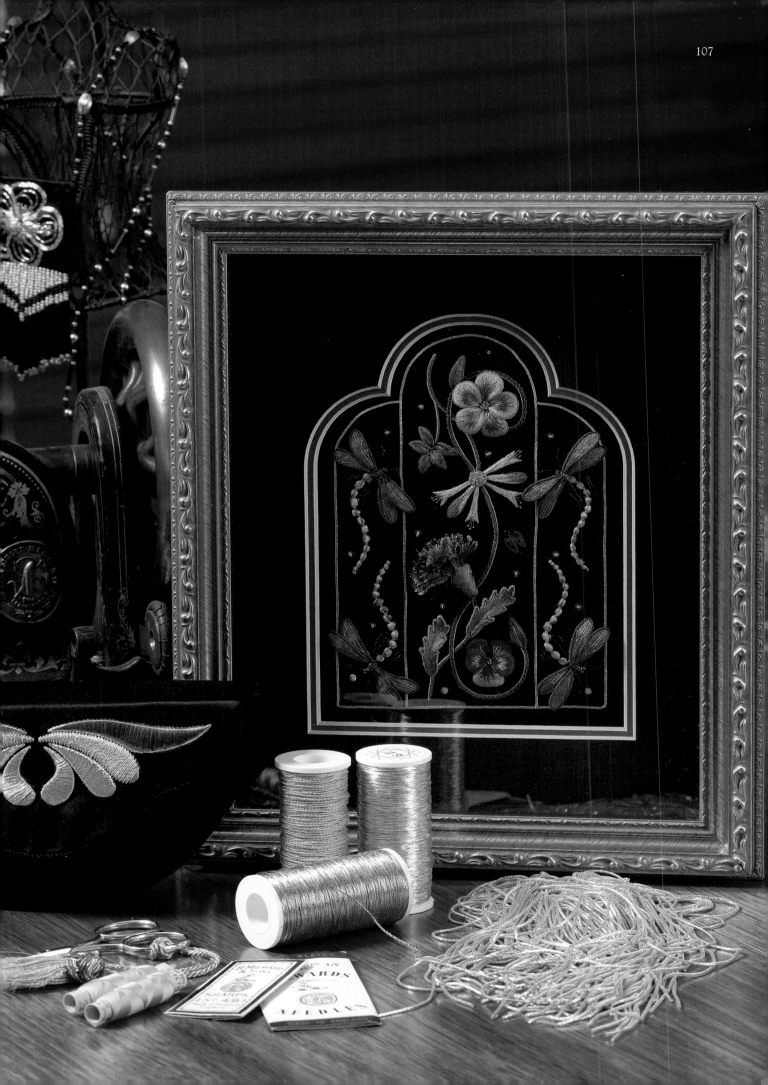

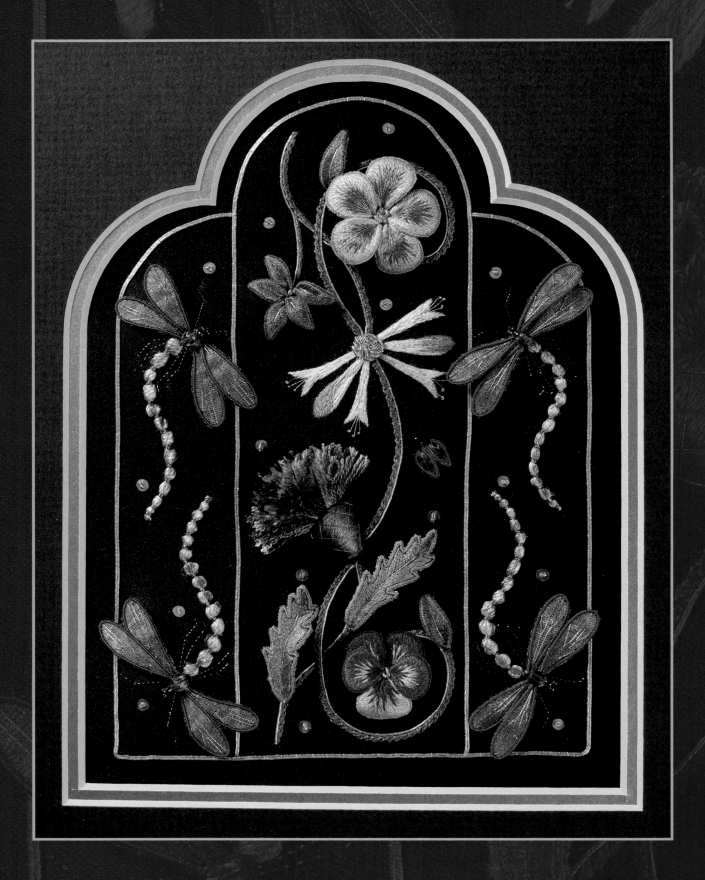

Window of the Blue Dragonflies

Window of the Blue Dragonflies

REQUIREMENTS

33 cm square black delustered satin

33 cm square quilter's muslin

2 x 22 cm squares quilter's muslin

28 cm square of turquoise glass organza

28 cm square of aqua pearl organza

20 cm square Vliesofix

5 cm square beige felt

Au Ver à Soie 1 skein each of: 616, 623, 645, 1343, 1344, 1345, 1843, 2115, 2543, 2925, 2932, 3024, 3025

Madeira #3: 1 pkt colour 3

Mettler Polysheen #40 thread: 1 reel 4116

Madeira Metallic #40 thread: 1 reel Gold 7

Gütermann Polyester or Silk Thread #968

DMC stranded cotton: 1 skein black 310

Rajmahal Stranded Art Silk: 1 skein 255

Cascade House Lamé Silk: 1 skein 9015

Cascade House Luminere: 1 skein 8680

Silf Butterfly Thread: 1 skein 415

3.5 m Smooth Passing Thread #6

20 cm Smooth Purl #6

4 x 6 mm glass faceted beads, aqua

Mill Hill ® Size 6 Beads: 16014

Mill Hill ® Antique Seed Beads: 03047

Mill Hill ® Petite Beads: 42029

25 Size #18 paillettes

3.2 m 28 gauge uncovered silver bead wire

7 x 30 gauge white cake wires

25 cm hoop

20 cm hoop

15 cm hoop

#8 & #10 crewel needles

#18 chenille needles

#10 beading needles

#28 tapestry needles

Design size: 12 cm x 17 cm

Place the delustered satin over the larger piece of quilter's muslin and place in the 25-cm hoop – the fabric must be drum tight. Transfer the design using yellow dressmaker's carbon [see page 16].

Hint: When tracing and transferring the design, use a ruler for the straight lines of the window to ensure that your tracing and transferring lines don't have any 'wiggles' in them.

Outlining Window Frame

Take a length of Smooth Passing Thread #6 and fold in half to double. Couch the inner arch first using Madeira #3, beginning by couching through the loop. The couching stitches should be approximately 4 mm apart. Leave tails of thread 2.5 cm long to take through to the back when you reach the base of the arch.

Hint: Remember when turning corners with the passing thread to turn each thread separately beginning with the outside thread [see page 20].

Next couch the outer arches, beginning at the top and working around in a continuous line. Take the ends to the back and secure.

Stems

For the main stem, using Au Ver à Soie silk 2115, work two rows of chain stitch beginning at the pansy and working up to the rose. (The stem goes under the thistle and the honeysuckle.) Then whip the two rows together as one.

Outline the inside of the stem with a single length of Smooth Passing Thread #6 couched with Madeira #3. Take the ends to the back and secure.

Work the thistle and honeysuckle stems in the same way, stopping and starting so that they appear to go under the main stem. The honeysuckle leaf stem is worked with a single row of whipped chain stitch.

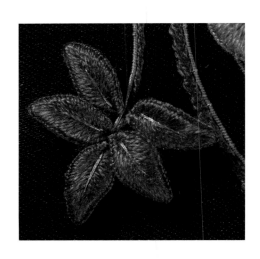

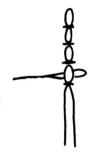

Dragonflies

Tails: Cut the Cascade House Lamé silk 9015 into five lengths 12 cm long and lay along the tail line. Thread up a #8 crewel needle with the Cascade House Luminere 8680 and couch the lamé silk at regular intervals, 'puffing' each section up by placing the eye of a #18 chenille needle underneath before tightening the luminere thread. Take the ends of the lamé silk through to the back with a chenille needle and secure to the muslin.

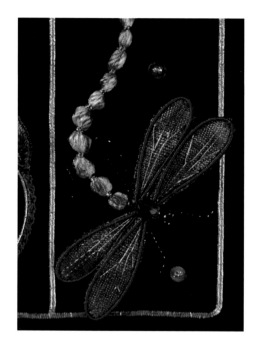

Wings: Fuse the two pieces of organza together at a 45-degree angle using the Vliesofix between two layers of GLAD Bake ®. Mount this into the 20-cm hoop.

Using the uncovered bead wire, mould the dragonfly wing shapes as per the pattern and tape in place on the organza. Using the Mettler Polysheen #4116, couch the wire around the wing shape and then overcast. Where the two wires come together, work five or six stitches over the both of them, holding them side by side. Work a buttonhole stitch to hold and leave the remaining thread on the surface of your embroidery for use to apply the wings to the base embroidery.

Using the Maderia Gold 7 thread, work feather/fly stitches for the veins on the wings.

Thistle

Cut two 65 cm lengths of Au Ver à Soie silk of each colour 1343, 1344 and 1345 and fold to double them (all six strands of all six lengths). Hold these over the thistle base outline and couch using 1 strand of Au Ver à Soie 1843.

Fold the long ends up and re-couch.

Cut and repeat a second time but stitch only two-thirds the distance of the first couching.

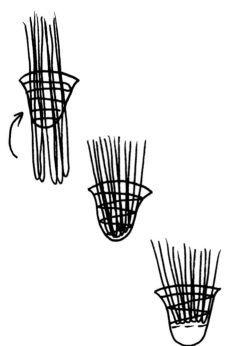

Cut a piece of beige felt as per the pattern sheet and using Au Ver à Soie 1843 apply over the top of the couched silk, stitching around the base and sides of the felt (not the top) [see page 17].

Using the same thread, work satin stitch horizontally across the felt until covered.

Using Madeira #3, work diagonal stitches across the thistle base making a diamond pattern.

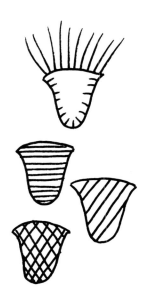

Thistle Leaves

Mount a piece of 22-cm square quilter's muslin into the 15-cm hoop and transfer the leaf shapes. Using a half-piece of covered cake wire and Au Ver à Soie 1843, couch the wire around the leaf shape and then overcast as for the dragonfly wings. Work split backstitch inside the wire edge and then fill in with satin stitch from the vein to the edge.

The leaf vein is worked with Madeira #3 – two strands – in a single long stitch from tip to base, couched in three to four places to hold in place.

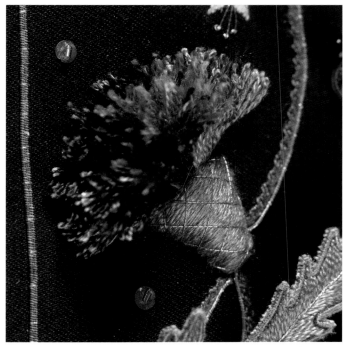

Honeysuckle

Outline the honeysuckle buds and florets with split backstitch using Au Ver à Soie 623. Work the honeysuckle buds in long and short stitch using Au Ver à Soie 3024 with highlights in 623 and 2543 [see page 27]. Work the florets in Au Ver à Soie 623 and 2543 in long and short stitch. Couch a piece of felt in the centre of the flower.

Embroider the stamens in Madeira #3 using pistil stitch, two wraps for the knot.

o – orange
p – pink
y – yellow

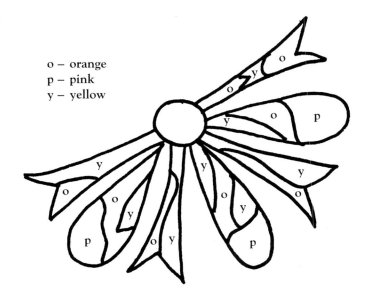

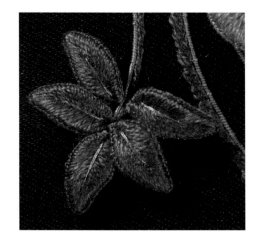

Honeysuckle, Pansy and Tudor Rose Leaves

Transfer the leaf shapes onto the 15-cm hoop alongside the thistle leaves. Using a quarter length of wire and Au Ver à Soie 2115, couch the wire to the shape with close stitches (approximately 2 mm apart). Next work a row of split backstitch inside the wire edge and then work in long and short buttonhole stitch, from the edge to the vein [see page 31]. The vein is worked as for the thistle leaves.

Tudor Rose

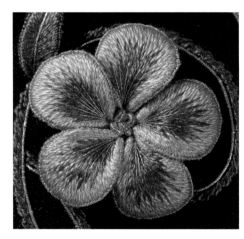

Transfer the petal designs onto the muslin in the 15-cm hoop and cut two pieces of wire into thirds (making six pieces). Couch closely as for the honeysuckle leaves, using Au Ver à Soie 2932. Work a row of split backstitch inside the wire edge and then work long and short buttonhole stitch around the petal.

Work a row of long and short stitch in Au Ver à Soie 3025 to fill in the petals and then add highlights in Madeira #3.

Pansy

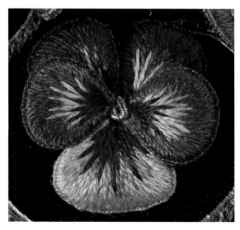

Transfer the petal designs onto the muslin and cut the wire into thirds. Couch the wire closely, work split backstitch and then work in long and short buttonhole stitch (as you did for the Tudor Rose), using the colours indicated on the diagram as a guide for the colour placement of each petal.

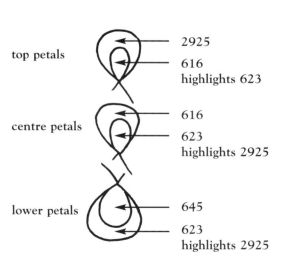

top petals — 2925
616
highlights 623

centre petals — 616
623
highlights 2925

lower petals — 645
623
highlights 2925

Ladybird

Cut out a sliver of felt and apply inside the oval on the main embroidery using DMC 310. Cut out the oval shape in felt and apply over the sliver, couching at the extremities first and then all around the shape.

Cover the felt shape with horizontal satin stitches and then with vertical satin stitches.

For the wings use Rajmahal 255 and a quarter piece of wire, couching the wire in the shapes as per the pattern sheet and then working a row of regular buttonhole stitch over the wire [see page 30]. Work a row of split backstitch inside the buttonhole edging and then work two French knots in each wing using two strands of DMC 310. Fill in around the French knots with Rajmahal 255 in long and short stitch.

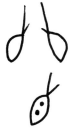

Applying detached pieces

Cut out the detached pieces carefully. Where detached pieces have a small tail of wire beside a long length of wire, you may trim off the small tail carefully.

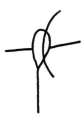

To insert the wires into the base embroidery, insert the #18 chenille needle so that the eye is halfway through the fabric, holding the fabric open. Pass the wires through the hole to place them in the fabric. Secure the wires to the underside of the embroidery by sewing them down about 1 cm and then bending the wire into a U shape and sewing down again. Do not cut off any wires yet! Where you are applying detached pieces near a stem, couch the wires to the underside of the stem.

Insert the flower petals of the Tudor rose first, placing them evenly around the circle shape on your base embroidery, leaving the centre clear. Apply the pansy next, starting with the base petal and then the two side petals over it – all through the same hole. The two upper petals are inserted just above that hole. Next, apply all of the leaves. Apply the honeysuckle leaves starting with the centre tip leaf first and working back towards the main stem.

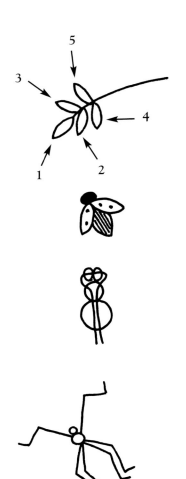

When inserting the leaves, insert the wire through the centre of the stem, not beside it. Insert the wings of the ladybird next, and then, using DMC 310, apply the black head bead.

Next apply the dragonfly wings to their tails on the base embroidery, using the left-over thread to secure to the back of the muslin.

Using one strand of DMC 310 apply an aqua 6 mm glass bead over the point where the wings are inserted into the fabric. Once secured, go through the aqua bead from the back and thread on one Mill Hill ® Seed Bead 03047, and two Mill Hill ® Petite Seed Beads 42029, and then go back through the seed bead and the aqua bead. Take the thread to the back of the work and secure.

Using one strand of the Silf Butterfly thread 415 in a #8 crewel needle, work the six dragonfly legs each comprising three straight stitches (as per diagram).

Finishing

Using a cutting pad, cut some lengths of Smooth Purl #6 about 5 or 6 mm long and stitch into the centre of the Tudor rose with waxed Gütermann thread. They should sit up as a loop, so stitch up and down through the same spot to make small hoops [see page 26].

Cut pieces of Smooth Purl #6 3-4 mm long to cover the felt in the centre of the honeysuckle. Stitch down randomly [see page 26].

The centre of the pansy is a single chain stitch using about 5 mm of Smooth Purl #6. Bring the needle to the surface in the centre of the pansy, thread on the length of purl and take the needle through to the back in the same place that you came through. The catching stitch of the loop is only the Gütermann Thread – if pulled down slowly and carefully, it should disappear into the gold purl.

Scatter the spangles/paillettes randomly and secure each with a 2-3 mm piece of Smooth Purl #6 (you may need a #10 beading needle this time).

Shape the petals, leaves and wings by gently stroking their underneath with a chenille needle while holding the tip. Now sit back and see if everything is where you want it to be. If it is, you can now cut off the excess wire underneath your work and visit the framers.

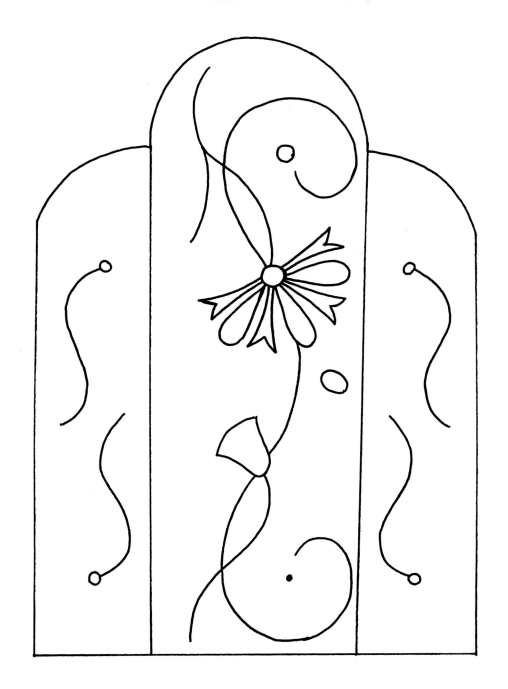

thistle pansy and rose honeysuckle tudor rose pansy dragonfly wings ladybird

x 2 x 2 x 5 x 5 x 1 x 4 x 8 each x 1 x 1

 ladybird thistle honeysuckle

felt shapes

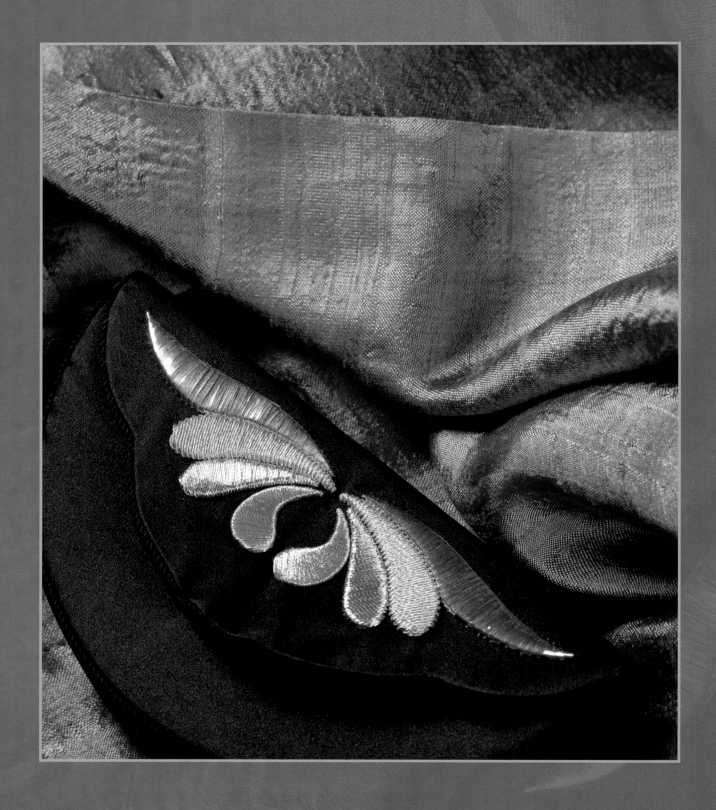

Clutch Purse

Clutch Purse

REQUIREMENTS

30 cm black delustered satin

30 cm square quilter's muslin

Gütermann Polyester or Silk Thread #968

Gütermann Polyester Thread Black

2 m Broad Plate (2 mm wide)

2 m #1 Twist

3 m Cotton on Creations Gold Couching Thread #608

Madeira #3: 1 pkt colour 3

DMC Stranded Cotton: 1 skein black

25 cm Pellon

30 cm x 45 cm template plastic

Magnetic bag clasp

#10 crewel needles

#18 chenille needles

9 cm x 16 cm cardboard

25 cm hoop

Craft glue

Craft knife

Reynolds ® Freezer Paper

Yellow felt-tip pen

Ruler

Note: Reynolds Freezer Paper is commonly used for patchwork and making cloth dolls. It is available from most patchwork shops

Trace the bag pattern pieces onto template plastic and cut out. Lay the templates onto the freezer paper and trace around the outside edge – the freezer paper needs to be cut out 2 mm larger than the template plastic, so don't place them too close together. Score the two lines marked on the bag back/flap template with a craft knife and the assistance of a ruler. Glue Pellon to one side of the template plastic shapes (the scored side of the back/flap).

Place a 30 cm square of black satin over the quilter's muslin and place in the 25 cm hoop, drum tight. Trace the pattern piece with the embroidery design onto GLAD Bake ® and transfer the embroidery design only with dressmaker's carbon [see page 16]. (By tracing the entire shape you can ensure that the complete piece is within the boundaries of the hoop.)

Transfer the individual shapes from the design onto cardboard and cut out. Depending on the thickness of the card, you may need to cut out two of each shape to place on top of each other. (I prefer to use two layers of a thinner card when working with curved shapes. With mount board, it can be difficult to get around the curves.) The finished thickness of the card padding is 1 mm – it doesn't sound much, but when the threads are laid over, it raises them the desired amount.

If using two layers of card, glue the matching pieces together and then colour the top and the sides with a yellow felt-tip pen. This will hide any small gaps in the embroidery (just like yellow felt).

Apply each piece of card over its respective shape on the satin using waxed Gütermann thread. It is correct that they do not touch – we are leaving a space for the threads to turn. The card can be applied in either of two methods: piercing with your needle in as many places as necessary to hold it in position, or (the method that I use) making couching stitches across each shape. Remember that the padding needs to be stable – if it can wobble or move around it requires more stitching [see page 19].

All embroidery is worked from the centre of the design outwards.

The plate, which is a ribbon of metal, is applied first. As it cannot be threaded through a needle it is couched onto the surface and then folded back on itself to hide the stitch. Note: When I apply the plate,

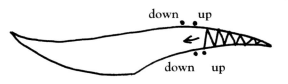

my stitches come to the surface on the inside of the design and go through to the back, working in the direction that the plate zig-zags.

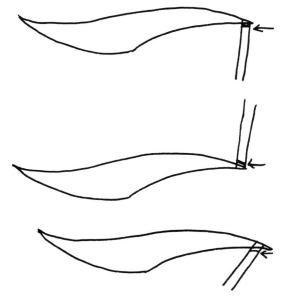

There are two ways that you can start: you can fold over a small hook of plate to couch through or you can begin by laying the plate over the tip of the design and couching on the lower side.

Fold the plate directly over itself to hide the raw end of plate and make another stitch. (At this point you have still made the hook, just broken it down into components).

This time, fold the plate on a slight angle, so that the plate moves down the shape but still hides the couching stitch and the card padding – it should overlap the last section applied.

Continue to zig-zag down the shape until it is covered. Be careful not to be too rough with the plate as the thread can sheer through it if you pull too tight. When you get to the end of the shape, cut the plate long enough to cover the last of the design AND to make a small hook in the end of the plate. Take your Gütermann thread through to the back, catch the loop of thread in the hook of the plate and take it down. Fasten off at the back. If the points need a little neatening, they can be squeezed gently with a pair of tweezers.

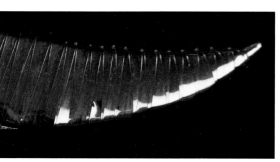

The #1 Twist is applied in the same manner, except that you can leave a 2.5 cm tail of thread to take through to the back with a chenille needle when you are starting and ending the couching. Note: When applying the twist and the couching thread, my stitches go in the opposite direction to when I applied the plate. I bring the needle to the surface a thread's distance away (in the direction that I am working) and take the needle down as close to the previous stitch as possible.

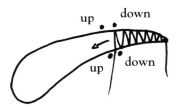
up down
up down

The tricky part with the twist, couching thread and Madeira #3 is the rounded end of the shape. When you get to this end, you will need to build up stitches to accommodate the depth of the padding – now you see why 1 mm is plenty of padding!

Apply the Cotton on Creations #608 couching thread in the same way as the twist.

The Madeira #3 is applied in satin stitch using three strands. Start a small distance away from the tip and work up to it, then work down to the rounded end.

Before you remove the fabric from the hoop, lay the tracing over the hoop, line up the embroidery and pin the tracing in place. Make a row of tacking stitches around the outside edge of the pattern piece so that you can put the freezer paper in the right place when working on the reverse.

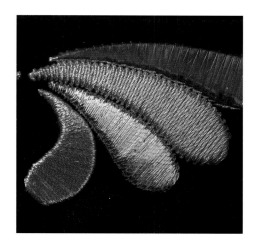

Making Up the Bag

Iron the freezer paper patterns for the front and the gusset onto doubled delustered satin (with the right sides facing).

Machine stitch around these pieces with a very small stitch, leaving open where marked for turning.

Trim as close as possible to the stitching and turn the pieces through to the right side. For the gusset, slide the template plastic (covered with Pellon) into the satin and close the opening with ladder stitch [see page 27].

The bag front needs to have the female half of the magnetic clasp applied where marked on the pattern. Then place the template plastic inside (Pellon side facing the clasp), and ladder stitch the opening closed.

Take the embroidered fabric out of the hoop and turn embroidered side down onto a doubled towel covered with tissue paper. Line up the freezer paper pattern inside the tacking stitches and iron on. Place the embroidered fabric over another piece of satin (right sides together) and machine stitch as for the previous bag pieces.

Trim close to the stitching, clip the curves and turn through to the right side. Apply the male half of the magnetic clasp where marked. Slide the template plastic inside the bag back/flap and ladder stitch the opening.

The bag is assembled using ladder stitch – stitch one long side of the gusset to the rounded side of the front, the other long side to the rounded side of the back/flap.

When the assembling is completed, make a fine twisted cord using black DMC stranded cotton and apply to the bag along the rounded edges and the sides of the flap.

open

open

open

template shape
bag back/flap

score line

score line

rectangle gusset template
4 cm x 27.7 cm

fold

template shape
bag front

open

open

open

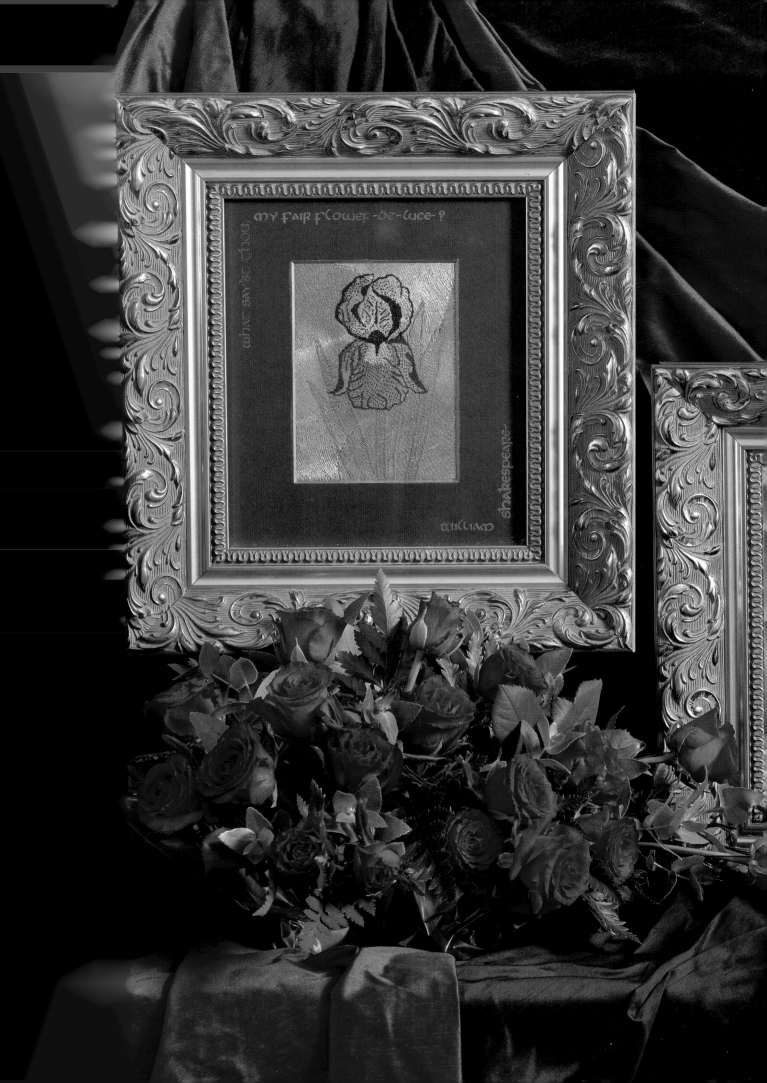

WHAT SAY'ST THOU, MY FAIR FLOWER-DE-LUCE?

WILLIAM SHAKESPEARE

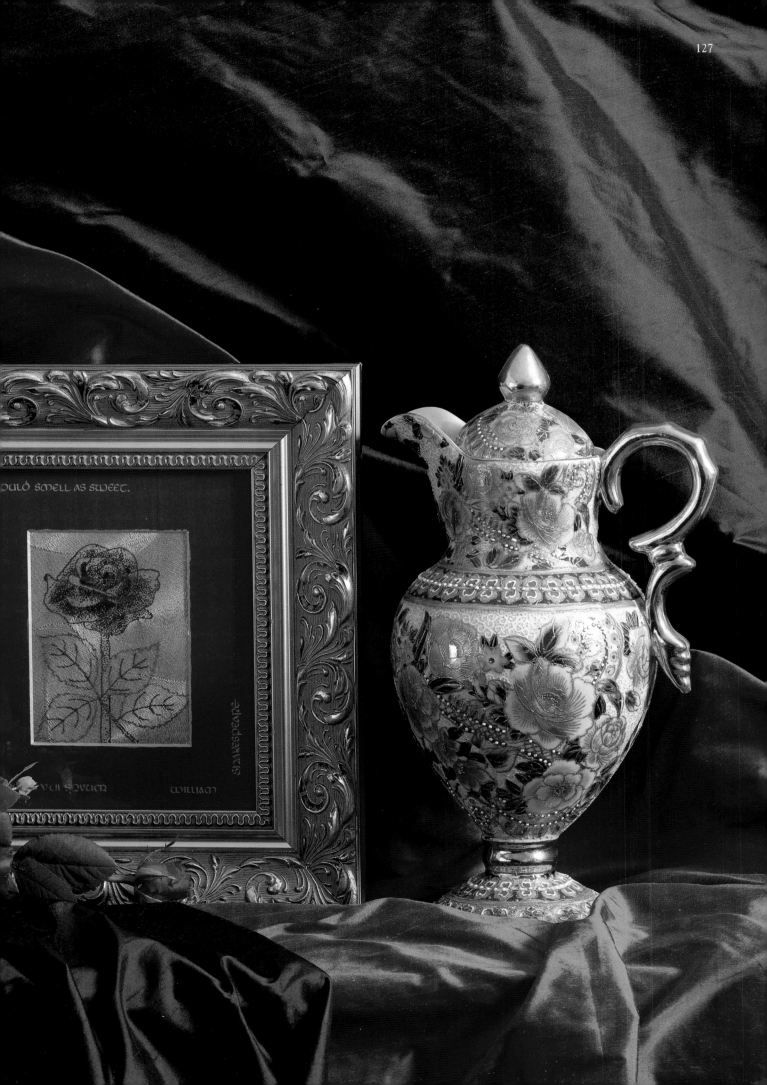

OULD SMELL AS SWEET.

SHAKESPEARE

WILLIAM

what say'st thou, my fair flower-de-luce?

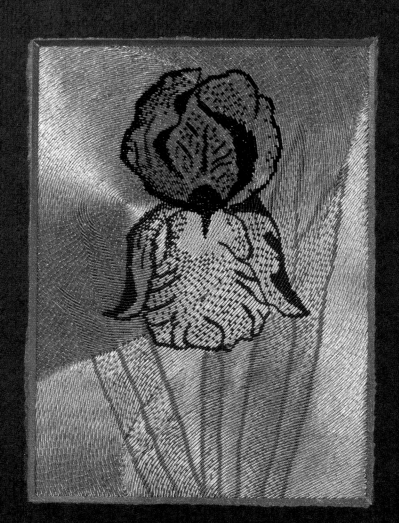

william shakespeare

Flowers from Shakespeare

Iris, Rose, Lily, Pansy

Flowers from Shakespeare – Iris, Rose, Lily, Pansy

REQUIREMENTS

28 cm square good quality calico

65 m reel of Smooth Passing Thread #6

Madeira #3: 1 pkt colour 3

Rose: Au Ver à Soie 944, 2115, 2626, 2925, 2926, 4615, 4625, Madeira Silk 1405

Iris: Au Ver à Soie 1316, 2114, 3316, Crème

Pansy: Au Ver à Soie 616, 2115, 2116, 4624, 4625, 4635, Noir

Lily: Au Ver à Soie 233, 616, 1845, 3041, 3425, 4626, Blanc, Crème

#10 crewel needles

#18 chenille needles

20 cm hoop

Black and Brown Pigma pens

Coloured pencils

Design size: 9 cm x 12.5 cm

Place the piece of calico in the 20-cm hoop, drum tight. Transfer the flower design, including the square/rectangle around it, onto the calico using dressmaker's carbon [see page 16].

Trace over the top of each of the lines with the black Pigma pen to ensure they are clearly visible.

Transfer the circle and wave designs onto the flower design, again using dressmaker's carbon. Retrace the circle and wave using the brown Pigma pen.

I have made the flower designs and the circle/wave patterns separate, as it is easy to confuse the two sets of design lines. Transferring them separately and in different colours means they are easy to distinguish.

Colour the elements of the design in their respective colours using the coloured pencils. This means that when small gaps are left in the couching process, they will not cry out and. 'Say look at me, I'm cream calico', but instead blend in and not be noticeable. Small gaps will be left in the gold areas when working Or Nué, as the silk that you are thread painting with is thicker than the gold thread that the background will be couched in. If you do not leave small gaps in the gold couched areas, you will get a 'wonky' shape because of the build-up of silk thread. This is not as noticeable when working with wave shapes as when working horizontal lines and circles, which quickly go out of shape if spaces are not left.

If you desire to work in the traditional method of horizontal lines, use a ruler to mark out parallel lines 0.5 cm apart over the entire design in the brown Pigma pen or a mechanical pencil to make sure that your couching lines are staying true.

It is best to have a separate needle for each colour on the go. It is also easier to leave the gilt smooth passing thread on the reel as you work – this means fewer ends to take through to the back of your work. Place the smooth passing thread in a small paper bag and pin to the side of your work – that way you won't get in a tangle.

Couch the design where required. Where a solid line is marked in pen – for example, a vein or petal outline – place the stitches close together like satin stitch. Where flower colour is coloured in pencil, place the stitches further apart to let some gold shine through. The

stitches of the coloured areas need not necessarily be couched in brick stitch; simply make as many or as few couching stitches as necessary to give you the depth of colour desired.

Where you want to show shadows, for example, a fold in a ruffled petal, stitch the darker shadowed area in solid stitching.

Couch the background gold in brick stitch using one strand of Madeira #3.

Note: I have worked the flowers using a single length of Smooth Passing Thread #6 rather than couching a doubled thread as with other projects. If working horizontally, you may choose to lay two threads at a time.

Begin by couching the outline of the circle – measure out 80 cm of smooth passing thread (but do not cut it off) and couch from the outline of the circle inwards, filling the circle completely using the

80 cm. When you reach the centre of the circle, the tail of passing thread can be taken through to the back of your embroidery by threading it in a #18 chenille needle. Secure to the back of your work by oversewing to the calico and stitching. Cut off the excess thread.

Go back to the outside edge of the circle and remaining smooth passing thread and continue to couch around the circle, changing colours as necessary, until you hit the wave line or the edge.

When you hit an edge, make a 180 degree turn outside of the rectangle design line and continue back in the direction that you have come from. When you hit the wave line, follow this line as you have followed the circle.

A very useful hint is to park the threads that you are not using on the top of your work in the spot where you will need them next. In this way you will not get them tangled up on the back of your work.

When you get to an angle that it too tight to turn the passing thread, you need to dovetail the passing thread. Simply work as far into the corner/angle as you can and then cut your thread, leaving a 2.5 cm tail to take through to the back of your work. Start the new thread in the same manner, leaving a tail, and continue couching.

Handy hint: Make a noose around the eye of the needle with the Madeira #3 so that if you drop your needle, it won't slip off the thread [see page 23].

Another last note on Or Nué. If, as you are working the design, you desire to make an area stronger in colour, you can go back and add a few extra couching stitches if desired. It is a whole lot easier than removing unwanted couching stitches at the end.